THE ULTIMATE GUIDE TO MASTER ASTROPHOTOGRAPHY.

The Ultimate Guide to Master Astrophotography is the ultimate manual for anyone looking to create spectacular landscape astrophotography images. By explaining the science of landscape astrophotography in clear and straightforward language, it provides insights into phenomena such as the appearance or absence of the Milky Way, the moon, and constellations.

This unique approach, which combines the underlying scientific principles of astronomy with those of photography, will help deepen your understanding and give you the tools you need to fulfill your artistic vision.

Table Of Contents

Why astrophotography?... 1

A brief history of landscape astrophotography............................. 4

 A quick guide to get you started tonight. 5

The night sky and its movement. ... 8

Overview of night sky objects. ... 10

 Stars and constellations. .. 11

 The brightest stars in the sky. .. 14

 Earth's annual orbit—How objects move during the course of the year. ... 14

 Seasons. .. 16

 Solstices and Equinoxes. ... 16

 Sunrises and sunsets. ... 18

 Azimuth Effects of Sky Color. .. 20

 Aurora Borealis / Australis. .. 20

 Origins of the Aurora. ... 21

 Predicting the Aurora. ... 22

 Viewing Tips and Alerts. .. 24

 The Moon. ... 25

 Moonrise and Moonset. ... 26

 Supermoon, Blood Moon, and Harvest Moon. 27

 The Moon Illusion. ... 28

Solar System. ... 29

Zodiacal Light. ... 30

Solar and Lunar Analemmas. 31

Light and the Human Eye. ... 32

Human Eye. .. 36

Camera and Lens Systems. .. 40

Camera Sensor. .. 40

Helpful Camera Features for Landscape Astrophotography 43

File Format. ... 43

Lens focal length. .. 44

Field of View. .. 45

Aperture. .. 45

Subject Distance. ... 46

Image Sharpness. ... 47

Focusing. ... 48

Optics of Focus. ... 49

Wide-Angle Lenses—14–24 mm. 50

24–70 mm Focal Length. ... 51

Exposure. ... 52

Camera Exposure Value, EV, and Matching EV to LV 53

Aperture. .. 55

Shutter Speed. .. 56

ISO. .. 56

- Developing your astrophotography session plan. 60
 - Pre-Visualization and Developing the Concept. 61
 - Choosing azimuth and altitude of the night sky subject. 63
 - Choosing the Location. .. 63
 - Choosing Lens and Camera Settings. 64
 - Developing the Landscape Astrophotography Workflow and Plan. .. 65
 - Essential Software and Apps. .. 66
 - Astronomy. .. 67
 - Photography—Processing Tools. ... 69
 - General Field Gear. ... 69
 - Astronomy gear. ... 73
 - Photography gear. ... 73
- Five best astrophotography targets and how to capture them. 75
 - Aurora Borealis/Australis. ... 75
 - Blue Hour. ... 75
 - Cityscapes. .. 76
 - Constellations. .. 76
 - Lunar Eclipse. ... 76
- Common Astrophotography Obstacles & How To Solve Them. 78
 - Logistics—Time, Travel, and Costs. ... 78
 - Setting Up at Night. ... 80
 - Focusing in the Dark. .. 81
 - Memory Cards and Batteries. ... 82

Other Issues. ... 83
Cameras And Imaging In Astrophotography. 85
 Conventional Digital Cameras. .. 86
 Remote Operation. ... 86
 Image Quality. .. 87
 Color Sensitivity. .. 90
 Light Pollution. .. 91
 Dedicated CCD cameras. ... 92
 Light Pollution. .. 93
 Color Sensitivity. .. 94
 Thermal Noise. ... 95
 Cameras for Planetary Imaging. .. 96
Please make sure to visit us at www.planetseekers.com 97

Why astrophotography?

The night sky is an essential part of nature and not just an astronomer's laboratory. However, for many people who live in urban light dominated areas, this part of nature is completely lost. Astrophotography in any form and level, either by only a photo camera and tripod or a complete set of telescopic equipment, helps to reclaim the forgotten beauty of the night sky.

There are few other scenes in nature that astound me so deeply in the way that the rise of the Milky Way does. People have photographed such fiction-like starry scenes from bizarre locations of the planet; from the boundless darkness of the African Sahara when the summer Milky Way was arching above giant sandstones, to the shimmering beauty of the Grand Canyon under moonlight, and crystal sharp sky of Himalayas when the bright winter stars were rising above the roof of the world Mt.

Everest. Astrophotography is not only about recording a part of the outer space. It leads you to a life of adventures and enjoyment which are not experienced by most of the people on this planet.

The age of digital imaging has revolutionized astrophotography. The possibility of creating inspiring images of the night sky with today's off-the-shelf digital cameras, which was once only possible with highly sophisticated equipment, made a considerable amount of public interest to amateur astronomy and astrophotography,

specially to nightscape (night sky landscape) imaging which is also often referred to as landscape astrophotography.

Landscape astrophotography combines compelling landscape subjects with carefully choreographed night sky objects. This guide explains the science behind the art of landscape astrophotography in clear and easy to understand language. The goal is to help you learn how to successfully plan and create your own nightscapes of the Milky Way, star trails, the Aurora Borealis, and much, much more.

The unique approach of this guide is its coupling of the underlying principles of astronomy and photography through practical, step-by-step methods to provide you with all the tools you need to fulfill your artistic vision. Without this knowledge, an inefficient, time-consuming and often frustrating ad hoc, trial and error approach is the only alternative to gaining expertise and proficiency in landscape astrophotography.

The theme of this guide is preparation. Understanding the basics of astronomy will give you deep insights into the "why" of the appearance or absence of the Milky Way, the moon, specific constellations, and more.

Learning the relevant fundamentals of photography will enable you to adjust your camera's settings for perfect exposures of the night skies. Thorough planning and preparation will guide you to the right place at the right time and with the right equipment and experience.

Far more than a cookbook of recipes, this guide delves deeply into the causes for the effects that you observe. This is accomplished through copious examples, detailed explanations and case studies. By mastering this knowledge, you will be able to predict with certainty, months and even years in advance, what you need to do; and when and where you need to go to create almost any new nightscape image you can imagine.

Finally, our hope in writing this guide is to convey our love of nature, photography, and especially the night skies. Through it, we hope that you, too, may gain a deeper appreciation of our incredible universe each time you step into the night.

A brief history of landscape astrophotography.

Landscape astrophotography has been around for decades. Prior to the advent of modern digital cameras, however, only the most dedicated possessed the patience to persist in their pursuit of quality images.

Success was elusive owing to the large number of obstacles and the steep learning curve, difficulties exacerbated by the major delay in image review resulting from the need to develop at least the negatives of the film. Nonetheless, the lure of the night sky was irresistible to many who carefully and meticulously perfected their art.

All this changed with the incredible improvements in affordable digital photography for the consumer market during the 1990s and 2000s. Suddenly, not only were digital single-lens reflex (DSLR) cameras available that were capable of producing images of comparable quality to those based on film, digital cameras provided instant feedback.

This latter point was a true game-changer; the photographer could now determine, on the spot, if the focus was off; if the exposure was wrong; if the composition needed to be tweaked, and so on. You will find yourself constantly reviewing your images in the field, and you will improve your success rate enormously if you develop the habit of doing so. You will detect and be able to correct

minor flaws that, if left undiscovered until you return home, could otherwise ruin an entire evening of shooting.

Today, landscape astrophotography, also known as nightscape photography, has exploded into our everyday lives—through science news, advertising, and social media. New apps and online resources designed especially for landscape astrophotography, especially those integrating augmented reality, are constantly being developed and improved. Camera and lens systems continue to be refined to be available at ever-lower costs. A host of online communities can be found to share and learn about the most obscure of landscape astrophotography topics. Clearly, this is a golden era!

A quick guide to get you started tonight.

Here is a straightforward recipe to get you outside tonight and embarked upon your landscape astrophotography journey. Fingers crossed for clear skies!

Description:
The starry skies have fascinated us for millennia. Here, you will want a clear view of the sky, and you will want to use a wide-angle lens, one with a focal length of approximately 24 mm or less for a camera with a full-frame sensor, or 18 mm or less for a camera with a crop sensor. Needless to say, you will want to mount your camera on a sturdy tripod!

What you'll achieve:
One to two dozen (or more) images of starry skies.

What you need:
Camera/tripod
Manual shutter release or self-timer
Manual exposure mode ISO 800–3200
Aperture—f/4, f/2.8 or similar
Shutter speed of say 5 seconds to start
Headlamp preferably with red light, or red plastic taped over a white light

Directions:
During the day, focus your camera on the most distant object you can see—the horizon, distant mountaintops, or distant city buildings. After finding a good focus, set your camera lens and/or camera body to manual focus and leave it there. Many people will temporarily tape the focus ring of their lens in this position to keep this focus for the duration of the night.

Next, before heading out, look up the time of sunset/sunrise. The skies generally become fully dark around 1½ to 2 hours after the sun has set. Plan on arriving on location at least an hour prior to this time to give yourself enough time to unpack, find a good location, and set up your camera system properly.

Set up your camera/tripod with a clear view of the sky; perhaps with an interesting foreground subject—a line of trees, mountaintops, or beach. If your camera doesn't have a viewfinder, don't worry. Just aim it so that it is generally pointing at the sky—and be sure to keep the manual focus setting in place! With your camera pre-focused as described above, expose your first image and review it and its histogram on the back of the camera.

If needed, increase or decrease the shutter speed—speeds of 20–30 seconds are very common. If the image is too dark at exposure times of say 20 seconds, bump up the ISO; just try to keep the ISO below 6400. If no clouds are present, you should be able to make at least a dozen or so high quality images. And if this doesn't yet make sense to you, it will; read on!

The night sky and its movement.

The night sky is rich with objects to observe and include in your nightscapes. There is the moon, meteors, the planets, comets, the Milky Way, and Iridium flares. There are dazzling atmospheric phenomena you may wish to pursue: the kaleidoscopic colors of sunsets and sunrises, deep twilights, the zodiacal light, sky glow, ice haloes, noctilucent clouds, moonbows, and the hypnotic Aurora Borealis/Australis.

Your understanding of the origins and characteristics of the objects and phenomena of the night sky; and how they move during each night, between one day and the next, and from month-to-month, will be the basis for your landscape astrophotography journey.

This section provides you with the astronomical foundations necessary for successful landscape astrophotography. First, we will briefly review the structure of the universe and how it relates to the most common night sky objects you will see.

Next, we will learn how the earth's motion—both its daily rotation about its axis, and its annual revolution, or orbit, around the sun causes these objects to move across the sky. We will see why this motion depends on the compass direction you're facing, or from which of the earth's hemispheres you're observing. You will learn about two simple tools you will want to learn how to use to

understand the constantly moving night sky and predict the constellations that will be visible for any time or date. Finally, we will conclude with a brief review of the cause and effects of the seasons.

Overview of night sky objects.

As the sun slips below the horizon and night descends, its light slowly recedes from the sky. The glowing blue gases in the earth's atmosphere become transparent, allowing us to peer into the realms beyond. What a universe awaits us! Moving beyond the earth, we first encounter our moon, along with our neighboring planets—Venus, Mercury, Mars, Jupiter, Saturn, Uranus, and Neptune.

Our solar neighborhood includes comets, which are frozen masses of gas, ice, and rock, as well as the debris they leave in their path that gives birth to annual meteor showers. Moving beyond the solar system into the encompassing Milky Way Galaxy, we find a rich variety of stars, gas nebulae, and star clusters. Finally, venturing beyond the Milky Way into deep space and the rest of the visible universe, we find ourselves in the realm of other galaxies and galaxy clusters.

All of these night sky objects can be put into one of two main categories for our purposes. The first category includes objects whose position relative to each other never changes —for example, the stars, the Milky Way, constellations, nebula, and star clusters.

Once you've learned their arrangements, they will be your familiar night sky friends for the rest of your life. The second category includes objects whose position constantly changes relative to the background positions of the stars. This category includes the planets, whose name originates from Greek for wandering star, the

moon, comets/meteors, satellites, and Iridium flares. This section focuses on the first category of objects, specifically, stars, and constellations. Subsequent sections cover the night sky objects whose positions constantly change.

Stars and constellations.

We begin with those objects whose position remains constant relative to one another: the glittering stars and the constellations they form. You may be surprised to learn that all the individual stars distinguishable with your naked eyes are only located within a relatively small portion of the Milky Way. Our eyes are only able to resolve galaxies in the vast space beyond the edges of the Milky Way in just a few instances. Einstein incorrectly considered the universe to be made up of a uniform "soup" of stars and occasional galaxies distributed within it.

It was Hubble who first discovered that this wasn't the case; rather, the universe was comprised of discrete galaxies with essentially no stars or much else 3 in between. In fact, nearly all the night sky objects you can see with your naked eye are relatively nearby stars, planets or other objects contained within our own Milky Way Galaxy, including our solar system.

The illusion of a universe filled with a moreor-less uniform distribution of stars is created simply by the necessity of viewing the night sky from our position embedded within the Milky Way Galaxy. Our view of the Andromeda Galaxy, M31, thus includes all the Milky Way stars that reside within our line-of-sight. If we were to view M31 from a position outside the Milky Way, none of the

stars would be present; we would simply see M31 floating alone in empty space.

The stars that make up the Milky Way, including our sun, are enormously varied in their color and brightness. Just look at the variety of stars in the constellations of Ursa Major and Scorpius. Some stars are brighter than others, depending on their size and proximity. Bear in mind that nearby, dim stars can have the same brightness as massive, dazzlingly intense stars that are much further away.

Second, all stars have a characteristic color, ranging from deep red to vivid blue. The color of each star depends entirely on its mass and age—young, hot stars give off a noticeably bluer light than the deeper reddish light of older, cooler stars.

The fact that hotter stars are blue while cooler stars are red may be opposite what you might think! Yet, owing to the peculiarities of human night vision, we perceive most stars as points of white light, with a few notable exceptions, such as the distinctly red gas giants Betelgeuse, Antares, and Aldebaran in Orion, Scorpius, and Taurus, respectively.

Your camera, however, has the capacity to record the true colors of all the stars—and its images will likely astound you! People have identified legendary figures, animals, and mythical creatures in the patterns of the stars across cultures for thousands of years. These groupings are called constellations, and some are most likely familiar to you. The International Astronomical Union established

eighty-eight constellations with internationally agreed upon boundaries nearly a century ago.

These constellations provide a useful structure for night sky navigation, in addition to their human interest. For example, we might say that Mars can be found in the constellation Leo on a given night, thus narrowing the region of the sky to examine. Each star within a constellation is ranked in terms of its brightness. The brightest star is generally designated by the Greek symbol α, the second brightest star by the symbol β, and so on. Thus, for example, the star Sirius, which is not only the brightest star in the constellation Canis Major but also in the entire sky, is designated Canis Majoris.

This information can be very helpful in pinpointing hard to see objects like comets, star clusters, and nebulae. For example, it greatly helps finding the North American nebula knowing it is near Cygni, or the second brightest star in the constellation Cygnus. There are many widely recognized sub-groupings of stars within constellations known as asterisms.

Probably the most familiar asterism in the Northern Hemisphere is the Big Dipper, which is part of the constellation Ursa Major. Other familiar Northern Hemisphere asterisms include Orion's Belt, the Teapot within Sagittarius, the Summer Triangle, the Winter Cross, and the Fishhook in Scorpius. Familiar Southern Hemisphere asterisms include the Southern Cross, the Southern Pointers and the Diamond Cross.

The brightest stars in the sky.

As we will see later in this guide, achieving proper focus on the stars can be extremely challenging. Part of the difficulty lies in the scarcity of visible, sufficiently bright stars to use as targets. Knowing where to find them throughout the year can help. Searching for the brightest stars is worthwhile, since they are your best option for achieving a sharp focus on the night sky. Although they may be hidden behind a foreground object, such as a tree limb or building, knowing their presence and simply moving a short distance away can often bring them into view. This process allows you to achieve correct focus and then return to your composition of interest.

Earth's annual orbit—How objects move during the course of the year.

So far, our discussion of the movements of the stars in the night skies has been confined to those that occur during a single night. What happens to our night sky view over the course of a year? This is easily answered by studying the changes that occur in our viewing direction as the earth orbits the sun. These changes affect what we see, just like the slow rotation of a revolving restaurant changes the view from its windows.

For example, in September, the constellation Aquarius is directly overhead at midnight, whereas in January, the earth has changed position so now the constellation Gemini is directly overhead at midnight. The night sky objects that are visible during different

times of year change simply as the result of the earth's motion along its orbit. Now imagine that we were somehow able to discern the stars during the daytime. The constellations that become visible lie on the opposite side of the solar system from the sun.

The sun would lie in the constellation that otherwise would only be visible at night, six months hence. For example, in January, the sun is positioned within the constellation Sagittarius which we see at night during July, six months later. In May, it is positioned within the constellation Aries, seen at night during November. The narrow band of the sky that includes the path of the sun's orbit, or the ecliptic, is known as the zodiac.

The twelve constellations found within the zodiac are known as signs of the zodiac, or sun signs, since the sun is positioned within each constellation during the different months of the year. Knowledge of the changing nighttime view throughout the year results in predictable seasonal events. Many are highly relevant to landscape astrophotography. For example, the brightest, central part of the Milky Way, or its core, lies beyond Sagittarius and Scorpius, thus becoming visible between March and September.

It is fruitless to attempt to photograph or even observe it during the rest of the year since it is obscured by the intervening sun and blue skies. Meteor showers only occur on specific dates and constellations are only visible during certain months, as we have seen. Consequently, it is extremely helpful to be able to forecast the appearance of the night sky for different dates throughout the year.

Seasons.

Seasonal effects are important for landscape astrophotography. Sunrise and sunset positions change throughout the year, as do daylight, twilight, and darkness durations. The 23.5° angle between the axis of rotation of the earth and normal to the plane of its orbit cause the seasons, not changes in proximity between the earth and the sun. The earth is actually physically closer to the sun during the Northern Hemisphere's winter than in the summer! Because of this tilt, as the earth moves around its orbit throughout the year, observers at different latitudes on Earth will experience more direct sunlight during some months than others. During the summer, those in the Northern Hemisphere receive.

the highest, most direct intensity sunlight since the sun is higher in the sky; and
For the greatest number of hours each day.

Conversely, in the winter, they receive much less direct sunlight and for fewer hours each day. An important outcome of the seasons is the changing position of sunrise and sunset on successive days during the year. This phenomenon can present a challenge to the landscape astrophotographer who wishes to capture the sun rising over a specific foreground object.

Solstices and Equinoxes.

There are four days during the year of special seasonal and cultural significance that can also provide unique landscape

astrophotography opportunities with great popular interest. The summer and winter solstices are the longest and shortest days of the year, respectively. The spring and autumnal equinoxes, on the other hand, are the days with equal lengths of day and night.

These important dates have been noted throughout human history, especially as they relate to the cultivation of crops. Stonehenge in England, the pyramids of Egypt and monuments throughout the southwestern deserts of the United States are just a few examples of the efforts of our predecessors to mark these dates.

One example of past civilizations marking the summer solstice is illustrated through a set of three, spiral rock petroglyphs inscribed in a rock boulder within an ancient Ancestral Puebloan village in southeastern Utah. The spirals are inscribed on an east-facing rock panel underneath an adjacent rock overhang. In turn, the rock panel is positioned a few feet to the west of a larger boulder which casts a shadow on the petroglyphs during sunrise. This unique rock geometry results in the formation of two "light daggers" that appear on either side of the eastern boulder's shadow, during sunrise on the summer solstice.

The positions of the three spiral petroglyphs were carefully chosen so that on the summer solstice, as the sun ascends and the light daggers lengthen and eventually intersect, they do so directly through the three spiral petroglyphs. This happens since the sunlight is able to pass over the front boulder and illuminate the rock panel. The different positions of the sun during the rest of the year preclude this sequence of events; the day when light daggers intersect the three spirals during sunrise confirms the summer solstice.

Witnessing events such as these immediately forges a timeless bond between the observer, those in the past who created them, and the reliable cycles of astronomy.

Sunrises and sunsets.

Undeniable feelings of renewal and hope accompany the sunrise; and comfort and peace with the sunset. It is no surprise that so much prize-winning landscape photography is created during these special times. This section explains the science behind the phenomena of sunrises and sunsets, and why they appear the way they do. Consider Earth's appearance from space. The half of the earth facing the sun is brightly illuminated and experiences daylight, whereas the half of the earth facing away from the sun is in the earth's shadow, and experiences night. Sunset or sunrise occurs in the day-to-night transition zones.

Clouds permitting, bright blue skies will cover the regions experiencing day owing to preferential Rayleigh scattering of the blue wavelengths of sunlight by the oxygen and nitrogen gas molecules in the earth's atmosphere. Dark, clear skies will cover the regions experiencing night as the result of the intrinsic transparency of our atmospheric gases coupled with the complete absence of sunlight-induced Rayleigh scattering.

During the day, the entire sky dome becomes a diffuse source of bright, blue light in addition to the predominantly yellow light of direct sunlight. When we're outdoors on a clear, sunny day, it's like we're in a giant amphitheater with a glowing blue ceiling! The

diffuse nature of the blue light from the sky allows it to illuminate observers who are shaded and thus not directly in line with the sun.

To observe this phenomenon, carefully examine a white sheet of paper outdoors in the shade of a tree or a building on a sunny afternoon. It will exhibit a distinctly bluish tint. If our sky had no atmosphere, shadows would be completely black, as they are on the moon, except for any light reflecting off nearby objects. So if the daytime sky is blue and the nighttime sky is clear, what is the source of the vivid oranges and reds of sunsets and sunrises? These colors appear because the light from the sun and adjacent sky that reaches observers during sunset and sunrise has traveled through a much greater distance of the earth's atmosphere than during the day.

As light travels through this greater portion of the earth's atmosphere during sunset and sunrise, most of its blue light gets scattered away and lost, thousands of miles away, before it reaches the observer. All that's left by the time the sunlight reaches the observer is predominantly red and orange light, with scarcely any blue light remaining. The greater the distance of travel, the more of its blue light is scattered and lost, leading to an increasingly red sun and sky as the sun approaches the horizon during sunset and sunrise. These fiery, final red rays of sunset and first rays of sunrise that strike high altitude mountains, and clouds are the source of the gorgeous phenomenon of alpenglow.

These beautiful orange, pink, and red colors only last for a few minutes before the sun slips too far out of position for these intensely colored rays to reach terrestrial and atmospheric objects. Nonetheless, these elusive colors are well worth pursuing—you

won't be disappointed! The distinctly warm colors of direct sunlight during the hour or so immediately before sunset and immediately after sunrise lead to these periods being known to photographers as the "golden hour." They create wonderful opportunities for award-winning images.

You can see this effect by comparing the two photographs; both created at the same location, but one during the harsh light of midday and the other during the warm light of the golden hour. Conversely, the approximately hour-long twilight periods just after sunset and just before sunrise are known as the "blue hour". The distinctly blue light from the sky during this period is the source of this name, since there is a total lack of any direct light from the sun. The blue hour provides many opportunities to create images with a very serene and calm mood.

Azimuth Effects of Sky Color.

The observer's azimuth, or compass direction, strongly affects the colors of the sky during the different periods of twilight. This phenomenon provides endless opportunities for nightscape astrophotography images. You can choreograph nearly any sky color combination you wish simply by selecting the appropriate period of twilight and azimuth!

Aurora Borealis / Australis.

The shimmering, dancing lights of the Aurora Borealis and the Aurora Australis are certainly one of the most mystical and

unforgettable phenomena of the night sky. The experience of witnessing cascading sheets of auroral light pouring over the dome of the sky has left many a night sky observer, including myself, speechless and in awe. Including an auroral display in a nightscape image is surely on the bucket list of most landscape astrophotographers.

Fortunately, aurorae are technically quite straightforward to photograph owing to their relative brightness compared to most of the other subjects described in this guide. In many cases, even a smartphone will suffice! It can be challenging to view the aurora, however, since they are restricted to specific regions of the earth, often necessitate significant travel and occur only sporadically. It can also be tempting to over-process aurora nightscape images with results that are unnaturally over-saturated and over-contrasted.

Popular locations for viewing the aurora with international air access include Fairbanks, Alaska; Yellowknife, Canada; Reykjavík, Iceland; Tromsø, Norway; and Kiruna, Sweden. Here, we will review the origins of the aurorae and the role of the earth's magnetic field so that we may predict when and where they are likely to occur.

Origins of the Aurora.

The sun is constantly hurling incomprehensible quantities of electrons, protons, and a host of other subatomic particles into space at immense speeds. While most of these emissions occur more or less uniformly over its surface, local disturbances, such as sunspots and flares, can cause locally concentrated outbursts of particles and

energy, and a temporary increase in auroral activity on Earth. The prevalence of notable auroral displays in a given year is thus strongly correlated with the manifestation of sunspots.

In turn, the number of sunspots fluctuates in a cycle with a period of approximately eleven years. The most recent maximum occurred around 2013; the next maximum is expected approximately in 2024. Of course, aurorae occur even without sunspots; there is simply a higher chance of a strong display when sunspots appear. Occasionally, the sun will "burp" and discharge a relatively large quantity of matter during an event called a coronal mass ejection (CME).

CMEs can be responsible for spectacular displays of the aurora. This is because of their particularly high density of high-energy particles. When the massive quantities of high-energy particles ejected from a CME reach the earth, their interactions with the gases in the earth's atmosphere are so extensive the result is called a geomagnetic storm. Another source of energy into the earth's atmosphere are solar wind streams from open coronal holes in the sun, although they tend to be less strong than CMEs. In either case, communications and electrical power distribution systems can be adversely affected and even disrupted during a geomagnetic storm.

Predicting the Aurora.

The near-term likelihood of an auroral display can be predicted by monitoring the surface activity of the sun, along with measurements of the magnetic fields of the earth and the sun. Vigilant aurora watchers monitor sunspot and other solar activity

closely for any signs of an impending CME or other significant solar event. If an eruption occurs, scientists and amateurs alike carefully calculate the trajectory of the outgoing stream of particles to assess whether or not it is likely to significantly interact with the earth's magnetic field.

Since aurora-causing particles have mass, they travel towards the earth at a fraction of the speed of light, and can take up to several days to arrive. In contrast, the light and heat emitted from the sun only takes a little over 8 minutes to travel from the sun to the earth. Consequently, aurora-causing geomagnetic storms can often be predicted up to several days in advance owing to the time required for CME particles to travel from the sun to the earth compared to the much shorter time required to visually detect the onset of a CME.

There are several space weather measurements constantly being made and analyzed to determine the likelihood of a near-term aurora display. Both the raw data and the results of the analyses are continuously generated from the U.S. Space Weather Center as well as the National Oceanic and Atmospheric Agency (NOAA), and are made freely available to the public in a variety of useful formats. You may wish to become familiar with how to access and interpret these rich sources of information. While none by themselves may be enough to predict a visible display with certainty, simultaneously favorable levels of two or more of the key indices can nearly guarantee a visible display.

Viewing Tips and Alerts.

Displays of the aurora occur every day of the year, day or night. However, most displays are insignificant and only visible at extremely high latitudes. Spectacular displays can also occur any day of the year and any time of night, although they are most commonly viewed after midnight owing to the dark skies, and around the spring and fall equinoxes.

Dates around the new moon each month also result in the darkest possible skies and allow the most vivid colors to be seen at a given location. A crescent or quarter moon may cast enough light to illuminate the foreground without overexposing the sky. Nights of the full or nearly full moon tend to wash out the aurora owing to the relatively bright skies. Stunning images are often captured of the aurora over a large, calm body of water that produces gorgeous reflections.

There are several free and subscription services that allow you to automatically receive alerts of impending auroral displays. These alerts can be very helpful when a display unexpectedly develops in the middle of the night and you happen to be asleep. Several online communities also exist to help alert their members to ongoing displays.

For example, one very active and popular Facebook group is the Great Lakes Aurora Hunters (GLAH) group, whose over thirteen thousand members actively report and generously share up-to-the-minute information and viewing tips. These are related to ongoing and imminent auroral displays across continental North America and

Alaska, Canada, and Scandinavia. Finally, there is the time honored "telephone tree" in which friends simply call one another to drag them out of bed during an active display!

The Moon.

Next to the timing of sunrise and sunset, the phase of the moon is the single most important factor for you to consider in creating your nightscape images. Especially if you're new to landscape astrophotography, the effects of moonlight on nightscapes can be surprising.

One reason for this is that both camera sensors and film accurately record moonlit nightscapes in full color, in contrast to human night vision, which perceives them primarily in black and white. The results can be pleasantly disorienting—otherworldly nightscapes that appear to be illuminated by sunlight, yet with skies clearly containing a multitude of stars!

Whether the moon is present or absent in the night sky when you make your nightscapes directly affects two of their most important aspects. First, when the moon is visible, it acts like a dim version of the sun, causing the gases in the earth's atmosphere to glow with a bluish tinge. However, this glow tends to drown out the dimmer night sky objects, resulting in fewer observable stars and other phenomena.

In contrast, when the moon is absent, the earth's atmosphere remains as transparent as window glass, allowing us to see all the way through to the inky blackness of space. Such conditions are best

for viewing the largest number of dim night sky objects, especially the Milky Way. Second, when the moon is present, its light richly illuminates the objects on the ground, compared to the much darker, nearly featureless foregrounds during moonless nights. Clearly, it is crucial for you to know how to predict whether or not the moon will be visible on any given night.

Moonrise and Moonset.

A special consequence of the timing of moonrise and moonset relates to the outstanding opportunity to capture the nearly full moon rising the day before or setting on the day of the full moon. At these moments, the moon can appear magically suspended in the earth's shadow, or floating between the earth's shadow and the Belt of Venus. Especially for the case of a Supermoon, or Harvest Moon, these photo opportunities can be real prizewinners!

A special note of hard-learned practicality however—the actual timing of the moment of moonrise relative to that of sunset/sunrise on these days can differ by 20–30 minutes from month to month, which can significantly impact the moon's position relative to the earth's shadow.

In fact, the specific moonrise/set when the moon rises in a position exactly straddling the boundary between the earth's shadow and the Belt of Venus may only occur once per year! So carefully consult your planning tools to pinpoint that one day when your shot may present itself. Oh, and keep your fingers crossed for good weather!

Supermoon, Blood Moon, and Harvest Moon.

You have probably heard of the "Supermoon," or "Blood Moon," and asked yourself what's the big deal? The answers are more societal than scientific. Along with other astronomical phenomena, the full moon has always played a prominent role in human culture, and notable annual events like these have given us a reassuring sense of the regular cycles of nature.

Each has its origin in a combination of astronomy and popular culture. As one example, let's consider the "Supermoon" designation, which in addition to appearing slightly larger than normal, has been credited with triggering natural disasters! Supermoons are full moon that occurs during the part of the moon's orbit when the moon is in the closest physical proximity to Earth, or at its perigee.

What's that? The orbit of the moon around the Earth isn't perfectly circular, but is actually an oval, or an ellipse.

As a natural consequence, there is one point when the moon is closest to (perigee) and one point when it is farthest away from (apogee) the earth. The difference in moon-Earth distance between these two points is about 50,000 km, which although not inconsiderable, only leads to a difference in apparent diameter of about 14 percent as well as a difference in apparent brightness of about 30 percent. This brightness difference isn't especially significant. Nevertheless, each full moon can provide you with an

opportunity to link the beauty of astrophotography with increasingly publicized popular culture.

The Moon Illusion.

Finally, no discussion of moon astrophotography would be complete without explaining the phenomenon known as the "Moon Illusion." The moon illusion refers to the purely psychological perception that the moon appears larger when it is nearer the horizon than when it has ascended high into the sky.

When we see the moon next to objects on Earth that decrease in size as they increase in distance from us, we interpret the moon as being enormous! This happens simply owing to the decreasing size of terrestrial objects through parallax. Once the moon has risen into the sky with no reference points, its size appears to shrink. You can use an index card with calibrated markings to "measure" the moon's diameter the next time it is full in order to test this phenomenon for yourself.

Be sure to hold the card at arm's length in order to get a consistent measurement. Now, during this or the next full moon, measure the size of the full moon when it is both next to the horizon and when it is overhead. When you compare measurements, you will see they are the same!

An interesting outcome of this exercise is the ability to develop a handy field guide to estimating the size of the moon relative to possible foreground candidates that might be good subjects to juxtapose with the full moon. If you repeat the exercise above but

simply with, say, the fingernail of one of your outstretched hands at arm's length, you will be able to develop an estimate of the size in of the full moon in comparison to the width of the fingernail.

For example, in my personal experience, the full moon is approximately half the width of the fingernail on the little finger of either hand when held outstretched at arm's length. This knowledge has proved invaluable during day scouting trips in preparation for a rising full moon nightscape image.

I simply hold up my hand at arm's length, and compare the size of half the width of my fingernail to the size of the foreground object. If they are roughly the same, then I know that the rising full moon will appear to be of equivalent size. One last point that should be made concerns the ability to photograph the details of the craters on the surface of the moon. These craters and mountain ranges are generally not possible to resolve even with common 100–300 mm lenses. Much higher focal length lenses, and even a telescope may be necessary.

Also, exposure bracketing is often required to simultaneously record images with sufficient surface detail of the full, or nearly full moon but that are badly underexposed for the foreground, and images correctly exposed for the foreground, or stars, but that show the moon as an overexposed, featureless disc.

Solar System.

It seems incredible that only just over four hundred years ago, all humankind believed in the geocentric model, which places the earth

at the center of the entire universe. It was only in 1609 that Galileo conclusively recorded the movement of Jupiter's moons around Jupiter, not Earth, proving that the geocentric model was wrong.

Of course, we now know that the sun is the center of our solar system, in what astronomers call the heliocentric model. In this section, we will briefly review the characteristics of our solar system to aid in our nightscape quests, including the differences between its eight planets. You will also learn about several new and striking astronomical phenomena associated with the solar system: planetary conjunctions, the zodiacal light, and solar and lunar analemmas.

Zodiacal Light.

The zodiacal light is a relatively rare phenomenon that is beautiful to behold. It is only visible under completely dark skies for an hour or so around when astronomical twilight begins or ends. The zodiacal light is a cone of diffuse, white light emanating upwards from the horizon above where the sun has set or will rise.

The zodiacal light, also known as the "false dawn," originates from sunlight reflected from vast fields of dust that lie along the midplane of the solar system, or the ecliptic. These dust fields are thought to be the remnants of comets that originate from far beyond the outskirts of the solar system, rather than leftover remnants of asteroids within the solar system.

The zodiacal light is best seen during the spring equinox during early astronomical twilight in the evening, and during the autumnal equinox during late astronomical twilight in the morning. The

zodiacal light is more prominent nearer the equator owing to the nearly perpendicular orientation of the ecliptic at tropical and lower latitudes. It is best photographed with a wide-angle or fisheye lens under extremely dark skies, far from city lights.

Solar and Lunar Analemmas.

A wonderful, but challenging, landscape astrophotography image is that of a solar analemma. Combining photographs of the sun taken at the same time on regularly spaced, clear days throughout an entire year allows you to create a solar analemma. They are the result of two completely independent features of the earth's motion around the sun:

its 23 ½° tilt about its rotational axis; and the ellipticity of its orbit.

The earth's tilt results in the figure-eight shape of the analemma, while the ellipticity of its orbit causes the asymmetry in the figure eight. The similar tilt of the moon and ellipticity of its orbit allows the creation of a lunar analemma as well. The main difference between a solar and lunar analemma is that the lunar analemma must be created, on average, 51 minutes later each day during one lunation, or lunar month, to result in the moon arriving at equivalent positions, whereas a solar analemma must be created at precisely the same time of day. This is the result of the fact that the moon rises approximately 51 minutes later on successive days.

Light and the Human Eye.

The ability of the human eye to perceive light is truly one of the wonders of nature. Incredibly complex and delicate, the human eye is sensitive to a remarkable range of light levels and detail. In order to understand how we perceive light and color, let's begin by considering light's basic characteristics— where does it come from and how do we describe it.

We will then explore the characteristics of the eye and human vision to better understand the components of compelling nightscape images.

Hue, Saturation and Scene Luminance, LV.

Photography is the collection and rendering of ambient light. Sources of ambient light are either direct sources, i.e. objects that emit light, or indirect sources, i.e. objects that redirect light produced from direct sources.

Examples of direct sources include the incandescent and luminescent sources described above. Indirect light source examples include light scatterers, like the sky and its atmospheric gases; light refractors, like atmospheric ice crystals and water droplets; and perhaps most commonly, light reflectors, such as the moon, satellites, planets, comets, people, mountains, lakes, and trees.

Light reflectors can be further classified as diffuse reflectors, such as trees, mountains, and people, where the reflected light is

sent in random directions, and specular reflectors, such as mirrors, where the incident light rays are simply redirected by reflection.

The light that enters our camera can be characterized by three main qualities: hue, saturation, and luminance/ lightness/ brightness/ value/ intensity. These, in turn, depend on the specific characteristics of the direct or indirect light sources within the camera's field of view.

Hue is what we think of as the color of light–turquoise water or a red headlamp. Hue has an infinite range of possibilities, depending on the hues of the constituent sources. For example, outdoor subjects in full sunlight have two different hues of light illuminating them: the direct white light from the sun and the primarily blue, scattered light from the sky. This combination is generally unflattering, which is why the best outdoor portraits are made under neutral, cloudy skies. The brightness of a direct or indirect light source is characterized by its luminance, also termed lightness, value, or intensity.

Luminance has nothing to do with color; two red and green objects can have exactly the same luminance. The luminance, S_x, is measured in units of lux, which simply indicates the amount of light available per unit area.

All the direct and indirect sources of light within a scene contribute to its total, overall brightness. The extraordinary sensitivity of the human vision system allows it to detect and interpret images with luminance levels ranging from less than 0.001 lux to well over 50,000 lux. However, this enormous range makes

luminance a completely impractical parameter for photography. The currency equivalent would be to conduct all your purchases, from sticks of gum to groceries to cars to real estate, solely with individual pennies!

Instead, photographers have devised a way to convert the luminance into a much more useful parameter called the light value (LV), which only ranges from −12 to +12 or so. A LV of −12 corresponds to near total darkness; a LV of +12 to blazingly intense light.

The LV is obtained from luminance simply by taking its logarithm: $LV = \log_2(\) = 1.44 \ln(\)$

where C is a calibration coefficient for the light-meter used to measure the scene luminance, safely assumed to be approximately equal to the number one. Following the example of currency, the LV would the equivalent of higher denomination coins and paper currency. The practical interpretation of the equation is straightforward—when the ambient brightness, or Sx, doubles, LV increases by one; when Sx quadruples, LV increases by two, and so on.

The fact that the quantity of light doubles or halves between individual LV levels has led to the designation of a one-LV difference in luminance as being one exposure stop, or one f-stop. In other words, when the LV changes by one exposure stop, the amount of light either increases or decreases by a factor of two. Since each scene contains of a unique set of direct and indirect light

sources, each with their own characteristic luminance, each scene will have a unique LV.

For example, typical nightscapes will include both direct light sources, such as stars, and streetlights, and indirect light sources, such as the moon, planets, mountains, and other foreground objects that reflect light originating from the direct sources. A key advantage of using light values as a measure of brightness in determining exposure settings in photography is that scenes with comparable overall lighting will have roughly equivalent LV levels, regardless of minor differences in light levels within the scenes.

For example, perhaps we have a scene with relatively abundant ambient light, such as is the case during late evening before the sun has set. It is a safe and practical starting point to assume that this scene would likely have a LV of approximately six to eight, regardless of the details of what's in the scene, or where in the world it's located. Or maybe we are attempting an image an hour after sunset during a waxing gibbous moon, where the foreground is dimly illuminated. In this case, our LV would be lower since there is less light, likely around −4 or so. Or possibly we are seeking an image of the relatively faint Milky Way during the middle of the night of the new moon, deep in the wilderness, far away from any city lights. Here, our light value would be even lower, likely around −6 to −5 or so.

This ability to characterize most landscape astrophotography scenes in terms of their approximate light value is extremely helpful to the next step of knowledgably setting your camera exposure settings in preparation for creating your nightscape image. The final

parameter of interest used to characterize light is its saturation, which simply refers to the vividness of its hue. If two different subjects have the same hue and luminance, but different saturation levels, the one with the lower saturation appears more wan, or "washed-out," than the other.

Human Eye.

The human eye has several characteristics worth appreciating from a photographic perspective, especially for night photography. Let's start with its anatomy. In many ways, the human eye is roughly analogous to a camera with many of the same features. It has a lens, an aperture stop (the iris), and a sensor (the retina). Missing is the shutter; our eyelids are simply part of a protective and cleansing system. Instead, our vision acquisition system functions in much the same way as a video camera, which also lacks a mechanical shutter.

Images are extracted from our retinas approximately twenty times per second and sequenced together by our brains to create the perception of motion. This ability provides the basis for motion pictures and video. By sequencing a series of still images at a faster rate than the retinal extraction rate of our brain, we are able to perceive the sequence of images as showing motion. If the sequence is animated at a rate slower than our brain's retinal extraction rate, then we are able to discern the individual images, and we recognize the animation as a sequence of still images rather than fluid motion.

The lens of our eye is truly a miracle of nature. It contains both living cells and inert, structural protein molecules arranged in such a

way as to be optically transparent and mechanically flexible. There are relatively few blood capillaries within the lens, owing to the need for optical transparency, which makes its regeneration relatively slow when damaged.

The curvature of the lens is what allows it to form an image on the retina. Since the lens always sits at the same distance away from the retina, its curvature must change to allow it to focus on objects that are at different distances away. This is accomplished through a series of small muscle groups connected between the lens and other regions of the eye. When the muscles contract, the lens stretches and becomes more flat. When the muscles loosen, the lens relaxes and becomes more convex.

This process constantly occurs as we focus on objects around us—even as you read these words! The iris of our eyes is the direct equivalent of the diaphragm in our camera. Both are mechanical systems that open or close depending on the desired quantity of light. The hole in the center of the iris is called the pupil; the hole in the center of the camera's diaphragm is called the aperture. The next time you look in the mirror, take a careful look at your pupil. Did you know that it is actually a transparent opening into your eye? Although obvious in retrospect, it is still amazing to think that with the right equipment you could actually look into your eyes in the mirror and see your retina!

The pigments in the cells that make up the iris are responsible for giving the iris its color. The pupil can range in size diameter from approximately 1.5 mm in bright conditions to 8 mm in dim conditions. It has a range of effective aperture from f/2 to f/11, with

a focal length of approximately 35 mm. A 35 mm camera lens on a full-frame camera is often considered to produce images having equivalent dimensions as human vision. The eye's retina is the layer of photoreceptor cells coating its inner, rear surface that converts light into biochemical signals that can be interpreted by our brain.

The retina contains two different types of cells: rods and cones. Both contain photopigments, proteins that change form when they absorb light. There are three types of cones, each with peak sensitivity to blue, green, and red light, respectively. Consequently, cones are responsible for color vision, although they are not as sensitive as rods to low luminance scenes. Although rods are much more sensitive to low light levels, they only yield vision in black and white, and have a peak sensitivity to blue light. How different our vision would be if our retina only contained one of these four types of cells!

Both sets of cells are concentrated in the retina in an area near the center of the optical axis of the lens, known as the macula. Within the macula is the fovea—the region of the retina with the very highest concentration of cones. There is a critical difference in how the rods and cones are distributed within the macula that produces important differences between our vision during the day and at night. The very highest concentration of cones is found at the center of the fovea, which helps us see with the greatest clarity of color during the day.

The very highest concentration of rods, however, are found in a donut-shaped ring surrounding the fovea, but approximately 20° away from its center. This fact has extremely important implications

for our vision at night. When we look directly at an object at night, we are relying primarily on the cones within the fovea to create our vision. If, however, we look slightly to one side of an object at night, or about the width of your thumb at arm's length, then the object's image falls onto this donut-shaped area with its extremely high concentration of rods, instead. This process is known as averted vision.

Since the rods are so much better at resolving images at night than the cones, we are able to achieve much higher image resolution at night using averted vision. Practice this a few times and you will soon appreciate the difference!

Finally, the process of dark adaptation by your eyes is a crucial part of night photography. Dark adaptation is the name given to the physiological process by which the rods in your retina increase their level of photopigments until they are nearly a million times more sensitive to light than in full daylight.

Dark adaptation takes around twenty minutes to become completely functional, and increases with time after that. However, it only takes a few seconds of exposure to bright lights to reverse your eye's dark adaptation. Also, since rods are relatively insensitive to red light, the use of red headlamps, or red cellophane taped over normal flashlights, allows the cones to function enough to assist with vision and yet maintain the dark adaptation of the rods.

Camera and Lens Systems.

Modern digital single-lens reflex (DSLR) cameras are truly masterpieces of technological innovation. Steadily improving year after year, today's DSLRs boast powerful sensors, sophisticated controls, and reliable performance at modest cost. The best news is that even entry level DSLRs today are easily capable of capturing the faint glow of the Milky Way, star trails, and the other nightscape images described in this guide.

The discussion on cameras in this guide is confined to those with digital sensors, since they have largely replaced film in landscape astrophotography. This section will review the essential features of DSLRs that are the most important in landscape astrophotography. We will review characteristics of camera sensors, focus and metering modes, lens characteristics and selection, and factors that govern image sharpness.

Camera Sensor.

The camera sensor is the heart of every imaging system. It is your camera's retina. The sensor is responsible for converting the image that the lens produces into electrical signals that are digitally analyzed and stored on memory devices. The sensor is a semiconductor device that has been processed so that its surface contains millions of individual pixels. Each pixel is a tiny optoelectronic device, often measuring only a few micrometers in dimension. Pixels are either etched out of the original silicon wafer,

built up with the deposition of additional layers of photosensitive and electronic materials, or both.

Incoming light is converted into electrical signals by each pixel in an analogous manner that the rods and cones in your eye's retina convert incoming light to biochemical signals. Furthermore, sensors contain red, green, and blue pixels, just like the red, green, and blue cones in your retina. The incident light upon each pixel is converted into an electrical signal representing the strength of the particular hue of light that the particular pixel received. By examining the relative values of the signals from immediately adjacent red, green, and blue pixels, the actual color of light incident upon the pixels, or its hue, can be reproduced in the same way the light would be perceived by a human retina.

The intensity of the light is determined by the absolute magnitude of the signals from each of the pixels. The pixels in the sensors are optoelectronic devices.

As such, they are inevitably susceptible to intermittent variations and false positives. Sometimes, they randomly indicate the presence of light when there is none. Other times, a high energy photon or other cosmic ray may trigger an event that the pixel records as light. In yet other instances, separate measurements of the same light levels can yield slightly different results.

In such cases, these artifacts are collectively known as noise, and are an undesirable, yet unavoidable consequence of digital imaging. The goal in imaging is to maximize the signal to noise ratio, or to limit the noise to a level that is so low that it is unnoticeable.

Sensors are characterized by several parameters, including the number of pixels they contain, their physical dimensions, and their signal-to-noise ratio. The number of pixels can be a very misleading parameter by itself, since small sensors can still contain a relatively large number of extremely small pixels.

While such sensors can produce acceptable photographs under bright light conditions, they are prone to very noisy performance in low light conditions, and are typically unsuitable for significant enlargements. These sensors typically find their way into consumer electronics such as cell phones and security cameras where noise at low light levels is tolerable, and the need for enlargements rare.

DSLRs with larger sensors that contain a high number of relatively large pixels are best suited for landscape astrophotography. Such sensors are typically referred to as full-frame, compared to crop sensors, which are roughly two-thirds the size of full-frame sensors. Large, full-frame sensors generally have very good low-light performance with much less noise than smaller sensors with smaller pixels. The best way to evaluate a sensor for landscape astrophotography, other than by price, is by examining its noise levels in images created in low light conditions at high ISO settings, characterizations that are frequently available online.

Helpful Camera Features for Landscape Astrophotography

There are several helpful and even critical camera features for landscape astrophotography. The most important is the ability to create exposures using manually controlled settings. Specifically, you need to be able to independently set the ISO, aperture, and shutter speed.

The second most important capability is the ability to manually focus the lens, which you will find yourself doing every night. Productive nightscape sessions are virtually impossible without these two vital camera features.

Having the ability to create quality images at the relatively high ISO settings of 3200, 6400, and even 12,800 is also helpful. Although such high ISOs are rarely used in other environments, they can be extremely valuable in landscape astrophotography. For example, you may find it helpful to create high ISO images of the night sky to blend in with low-ISO images of interesting foreground subjects.

File Format.

It is a near certainty that the DSLR you will use for landscape astrophotography will allow you to record your images in either a JPEG or RAW file format. I strongly urge you to consider the benefits of always using a RAW file format for your images

henceforth, whether or not you also save a second copy in a JPEG format.

The fundamental difference between these two file formats is in image quality. Images created in a RAW file format contain the maximum possible image information. The signal from each RGB channel of each pixel is separately measured and saved.

In contrast, the vastly smaller size of JPEG files is achieved through significant averaging of values from adjacent pixels with similar signals, in other words, file compression. Unfortunately, file compression irreversibly deletes sometimes-valuable information through its process of averaging. While cumbersome and bulky, the extra size of RAW files provides the maximum latitude for post-processing of images.

Lens focal length.

There are a few key lenses that you will want to include in your landscape astrophotography arsenal. Each one has specific features that make it advantageous for specific instances. Lenses are characterized mainly by their focal length, f. The focal length is the distance between the center of the lens and the focal point for parallel incoming rays of light, F. It is an inherent property of the lens.

The focal length should not be confused with the subject focus distance, o, which is the distance between the center of the lens and the subject. The focus distance changes with each subject, and can

range from a few inches to infinity, whereas the focal length is a fixed property of the lens and never changes.

Put another way, three lenses with focal lengths of 16 mm, 50 mm and 200 mm, respectively, can all have the same subject focus distance of 35 feet for a subject 35 feet away from the center of the lens, even though their focal lengths are all different.

Field of View.

The focal length is an extremely important parameter. It controls many other key lens characteristics, including its field of view (FOV). The FOV is the angle between lines connecting the camera to opposite sides of the image. Telephoto lenses have a very narrow FOV of only a few degrees, while wideangle lenses can have FOVs well over 100°. In addition to influencing the overall feel of your composition, the FOV can be very important in planning the basic feasibility of a given nightscape project.

For example, knowing the FOV of your lens can help determine whether or not a certain combination of constellations will fit into a single image created by that lens, or whether the North Star will fit into the same image as the horizon during a star trail composition.

Aperture.

The maximum possible aperture, or the smallest f-stop, of the lens is another key lens criterion. The f-stop is calculated by dividing the focal length of the lens, f, by the diameter of the

aperture, D. For example, a lens with a focal length of 100 mm and an aperture set to a physical dimension of 25 mm will thus have a f-stop of 100 mm/25 mm = f/4.

The reason behind the nomenclature of the f-stop, f/, is now clear; the diameter of the aperture is defined as focal length, f, divided by, or "/", the f-stop number. Thus: f/! You can also now appreciate why lenses that have a smaller minimum f-stop are so much more expensive; they simply use more glass that must be shaped and polished to optical perfection over a larger lens potential opening.

To see an example of this difference, let's consider two 35 mm lenses, one with a minimum f-stop of 1.4 and the other with a minimum f-stop of 4.5, such as those commonly sold as a kit lens with entry-level DSLRs. For the first lens, the maximum aperture (minimum f-stop) is 35 mm/1.4 = 25 mm, or approximately one inch. For the second lens, the maximum aperture is 35 mm/4.5 = 7.8 mm, or only about one-third of an inch. The second lens, therefore, uses much less glass and thus is inherently cheaper and less demanding to manufacture.

Subject Distance.

When choosing a lens and subject distance combination for landscape astrophotography, one important issue that bears consideration is the size of your foreground subject within your composition

Image Sharpness.

The aperture setting affects the resultant image's overall sharpness and quality, even when in perfect focus. There are two competing phenomena that cause this result: lens imperfections at minimum aperture and diffraction at maximum aperture.

When the aperture is wide open, i.e. at its minimum value, light passes through nearly the entire body of the lens to reach the sensor. In contrast, when the aperture is set to higher values, for example f/8, or f/11, we say that the lens is "stopped down" and the physical size of the aperture is smaller.

The aperture now blocks incoming light from the periphery of the lens, so that only light that impinges upon the central region of the lens is able to pass into the camera. The front surface of any lens at its periphery is naturally more curved than its center, which is nearly flat. A number of unavoidable lens imperfections, specifically, spherical aberrations, chromatic aberrations, and coma become important as the result of the greater lens curvature accessed at minimum aperture.

Spherical aberration causes a noticeable softening of the focus in the image. It results from the inability of light from the entire front surface of the lens to converge precisely at a single point within the image. Chromatic aberration is an optical phenomenon with its origins in the wavelength-dependent refractive index of optical glass. Images exhibiting chromatic aberration exhibit noticeable colored fringes surrounding bright objects, such as stars. Coma is the result of light sources, such as stars, that are located around the

periphery of the images failing to focus in a single point but rather in a flareshaped area at minimum aperture, and has its origins in the spherical aberration described above.

Finally, lens vignetting becomes more pronounced at minimum aperture since off-axis light travels through more glass and decreases in intensity, coupled with the tendency of the lens housing to partially block light entering near the lens periphery. Even the very best lenses exhibit these various effects at minimum aperture, although their effects are far more pronounced at the lowest minimum apertures, e.g. f/1.4 or f/2.0. In contrast, at the very minimum aperture dimension, i.e. maximum f-stop (e.g. f/22), the aperture diagram is now reduced to a narrow restriction. In this case, optical diffraction occurs around the edges of the diaphragm blades, producing noticeable softening of the image focus.

Although diffraction occurs at any aperture setting, its effects become minimized by the relative abundance of light from the bulk of the lens far from the diaphragm blades at wider apertures.

Focusing.

Learning how to achieve a good focus in the dark, whether it is on the stars, or on foreground subject, is probably the most difficult challenge to confront landscape astrophotographers. It is very important to learn how to achieve and confirm the best focus possible. While the compressed JPEG image on your camera's rear screen may look perfectly acceptable, examination at full scale on a monitor may reveal an image with visibly out-of-focus stars.

Optics of Focus.

Nightscapes are appealing precisely because of their in-focus foreground coupled with an in-focus night sky. Foreground objects can be out of focus if they are too close to the camera when the lens is focused on the sky. This section describes the two main approaches to reliably achieving sharp focus across the entire image—what to set and what to guard against.

In order to understand the camera and lens settings that control the near focus distance, let's introduce a few parameters needed to describe the physics behind the optics of focus. We've already introduced the object focus distance, o, and the lens focal length, f.

The depth of field (DOF) is the distance between the far and near focus points, bf, and bn. Second, we will assume the night sky lies at an infinite distance from the camera. Finally, we need to introduce the term, circle of confusion (CoC). The CoC is simply the size, or diameter, of the smallest circle that is resolvable by your camera's sensor. Put another way, if a distance corresponding to the CoC separates two tiny dots of light on your sensor, they are distinguishable as two separate dots.

If they are moved any closer together, they blend into a single dot. You may like to think of the CoC as the resolution limit of your camera's sensor.

It is roughly equivalent to the pixel dimension, or alternatively, as the approximate size of the rod and cone cells in your eye's retina. Consequently, it makes sense that if two tiny dots of light are

incident on a single cone cell, there is no way for that cell to know if there are two dots of light, one dot of brighter light, or even eighteen dots of dimmer light! In contrast, if the two dots of light are placed on two separate cells, then they are easily distinguishable.

Objects appear in focus if each point within them is focused to a spot smaller than the CoC, since they can then be distinguished by separate pixels. They appear blurred, or out-of-focus if their focused spot is larger than the CoC, and thus spread over more than a single pixel.

Consequently, the DOF is determined simply by the distance between the closest, and farthest away objects whose images are focused to spots smaller than the CoC. The first approach to achieving sharp focus across the entire image is to focus directly on a star, a planet, or the moon.

These objects are effectively at a subject distance of infinity. The next step is to look up the near focus distance for the relevant combination of lens focal length and aperture setting. Being sure that all the foreground elements within your composition are further away from the camera than this distance will ensure that they remain in focus while your camera is focused on the sky.

Wide-Angle Lenses—14–24 mm.

Wide-angle lenses in the 14–24 mm focal length range are favorites of most landscape astrophotographers. Without the major distortion of the fisheye lens, wide-angle lenses can simultaneously

capture wide swaths of the night sky and relatively undistorted foreground subjects in a single image.

They excel at capturing sunsets and sunrises; Milky Way images, star trails, meteor showers, and nightscapes of the aurora. Images involving the rising or setting of the full moon, however, are best shot with longer focal length lenses, since the moon becomes lost in such a wide FOV. Lenses in this focal length range are available as either prime or zoom lenses. They are also available with a range of apertures, some as low as f/1.4. Depending on your budget, these lenses are excellent investments, and rarely fail to satisfy.

24–70 mm Focal Length.

Owing to their more restricted FOV, lenses in the 24–70 mm range tend to be chosen when specific night sky objects make up the essence of the composition. They make excellent choices for nightscapes involving the rising and setting of the full moon, star trails, and images including the galactic core of the Milky Way.

They are also valuable when photographing local regions of the aurora. Finally, they are perfect for creating images used for panoramas. Another advantage of lenses in this focal length range is that they are widely available as prime lenses with very low minimum aperture, some as low as f/1.2. The fully manual versions of these wide aperture lenses are also quite inexpensive and are very well worth considering since you will rarely be using auto focus during your night sky forays.

Combining two or more images from such lenses in a panorama can offset the substantial coma distortions that occur at the lowest aperture settings. The central, sharpest regions are preserved, along with the extraordinary light-capturing ability of these lenses. Greater than 70 mm Lenses with a focal length above 70 mm are relatively uncommon in landscape astrophotography.

One reason is that many night sky objects are simply too large to fit into their relatively restricted FOV. Another reason is that relatively short exposure times are necessary to avoid significant streaking or trailing of stars. One area where these focal length lenses excel, however, is in creating nightscapes involving the rising and setting of the full moon. In such compositions, the requisite relatively short exposure times coupled with the need to isolate the area of the full moon rising or setting are both perfectly satisfied by lenses with relatively long focal lengths.

Exposure.

Knowledgeable exposure is the core skill of quality photography. Achieving the right combination of light and shadow that matches, or even amplifies, your artistic vision is the essence of success. In this section, we will focus on what you need to know about photographic exposure to truly master landscape astrophotography.

Camera Exposure Value, EV, and Matching EV to LV.

The primary photographic challenge, especially in landscape astrophotography, is to collect the right amount of light to produce a properly exposed image, regardless of the amount of light originating from the scene.

Historically, a "properly exposed" image is one with an overall brightness that is 18 percent gray, or 18 percent of the way between black and white. When we view scenes with differing light values with our eyes, our vision system handles this light collection and conversion process automatically; for example, our irises dilate/contract and our retinas become more or less sensitive.

In photography, however, this process is done by the photographer, and is accomplished by setting the exposure value (EV) of the camera to correspond to the light value (LV) of the scene. The EV depends mathematically on the ISO, I, aperture, A, and shutter speed, T, according to the logarithmic relationship: $EV = \log2(\)$.

To summarize, when we match the camera EV to the scene LV, we are assured of obtaining a correctly exposed image, i.e. one that is on average 18 percent gray, even if the subject scene is extremely dark or bright. The overall brightness of the resultant image will be the same.

Now, in practical terms, rarely, if ever, will you need (or want) to actually calculate your camera's numerical EV, since your camera's built-in light meter and analysis system does all the work for you. Instead, by taking a light meter reading of the scene of interest, you will be shown whether your current combination of ISO, aperture, and shutter speed is suitable to match the scene LV, or if it is too high or too low and you might wish to make adjustments. However, your understanding of:

(a) the LV levels of typical landscape astrophotography scenes and.

(b) what combinations of ISO, aperture, and shutter speed are available to match them.

will be of enormous value in planning and avoiding a frustrating night of trial-and-error in the field while your subjects slowly slip below the horizon in front of your eyes!

By way of example, imagine that we want to create a nightscape image with the Milky Way on a moonless night. We know that scenes such as these typically have an LV in the range of approximately −8 to −5. Therefore, we know that in order to match this light value to obtain a properly exposed image, we should set our camera to a corresponding EV of approximately −5. If our camera's EV setting is set to correspond to a much dimmer LV, for example −12, the resultant image will be too bright.

This is because the camera is set to receive less light than it actually would receive, like walking around in daylight with dilated pupils. On the other hand, if the camera's EV setting is too high, say

−2, then the resultant image will be too dark. In this case, the camera requires more light than is available for a properly exposed image.

Aperture.

In the vast majority of cases, you will want to set as low an aperture number, or f-stop, as is feasible. Notice I did not say as low as possible but feasible. There is an important difference. A low f-stop corresponds to an aperture that is physically large or wide open.

So why not simply set the aperture to its minimum value, for example, f/2.8 or even f/1.4 to allow as much of the ambient light from the scene into our cameras as possible? You will recall that one reason is that an aperture set to its minimum value can allow lens imperfection effects, especially apparent in astrophotography. Also, images made at minimum aperture can appear noticeably softer, which, for example, can impact the appearance, or crispness, of the Milky Way.

Consequently, the best compromise between coma and a too-restricted aperture is generally to set your aperture to one to two stops above the minimum aperture of the lens: for a lens with a minimum aperture of f/2.8, that would be f/5.6; for one with a minimum aperture of f/4, that would be f/8.

Shutter Speed.

The only real limitation on shutter speed, or exposure duration, in most landscape astrophotography images relates to undesirable effects of moving subjects. Distracting artifacts can manifest themselves as either unwanted streaking/trailing of stars or blurred foreground objects resulting from wind or other motion. In either case, keeping the shutter speed below a certain value will eliminate the appearance of movement. However, owing to restrictions on aperture such as coma, it may be necessary to keep the shutter open long enough to obtain a correct exposure.

So, how long a shutter speed is too long? For years, the practical "Rule of 400/500/600" has been the go-to guide for estimating the maximum exposure length that can be implemented without noticeable star trails.

The idea is simple; just divide the number 400, 500, or 600 by the focal length of the lens (in millimeters) to obtain the maximum shutter speed (in seconds) that may be safely used. Using the number 400 gives the most conservative estimate and is my recommendation for those with higher resolution cameras; using the number 600 may suffice for less critical audiences.

Note: for users with crop sensor cameras, you will need to multiply the lens focal length by the crop factor (generally 1.5 or 1.6) to arrive at the correct focal length to use in the Rule of 400/500/600.

ISO.

The ISO setting refers to the overall sensitivity of the camera sensor to light, and dictates how much light is needed to obtain a properly exposed image, or one that has an overall gray level of 18 percent. So why not simply set the ISO to the maximum possible setting? Images made with a low ISO setting need lots of light. The results are images with very high resolution, in other words, images that can be enlarged without losing detail or revealing pixel noise or grain.

In contrast, images made with high ISO generally suffer from distracting graininess and often visible color noise. Why is this the case? Think of it as if you were making a painting made up of individual dots of paint. With high ISO images, you're only allowed to use, say, 1,000 individual drops of paint to make up your painting, and so you have to use a fairly coarse brush.

With a low ISO image, you would need 1,000,000,000 drops of paint and thus you are able to use an exceeding fine brush capable of exquisite detail. Herein lies the origin of the higher inherent quality of low ISO images, and their ability to be enlarged significantly without a loss of detail. Finally, images made at higher ISO settings exhibit less dynamic range and less color contrast, and have less capability for significant adjustments during post-processing.

Selecting ISO, Aperture, and Shutter Speed for Optimum Image Quality.

It's time to synthesize this knowledge into a cohesive strategy for producing the best possible landscape astrophotography image given the local conditions. Here are the key points so far:

Matching camera EV to scene LV is the priority for a correctly exposed image

Low ISO is better than high ISO, to minimize graininess and color noise

The shorter the shutter speed the better, to minimize star trailing and foreground blur

Best aperture is two stops above the minimum, to produce distortion-free images

We are now prepared to see how this knowledge is applied in the field. Since we know what settings produce the highest quality images, why not just set the ISO to its lowest value, say, ISO = 100, set the aperture two stops above the minimum, say f/5.6 for a lens with a minimum aperture of f/2.8, and the shutter speed of the longest value needed to avoid star trailing, say 30 seconds for a 20 mm lens?

These settings result in a camera EV of EV = 0. Unfortunately, a great many landscape astrophotography scenes have much, much dimmer LVs, such as LV = −6 for scenes involving the Milky Way on moonless nights. This is a very significant difference; a camera set to an EV of 0 will unacceptably underexpose such a scene and will not work.

Consequently, we enter the arena of intentional trade-offs in camera settings. Suppose we bump up the ISO - how far can we go before the graininess is noticeable? How about the aperture - can we open it up more without terrible effects? And so on.

Once you have experienced this process a few times under night sky conditions, you will develop your own set of references to refine and return to time after time. Remember, the goal is to maximize the time in the field acquiring images and minimizing the amount of time adjusting the exposure settings!

Developing your astrophotography session plan.

This section helps you develop a detailed plan for your nightscape session based on your understanding of astronomy and photography. It includes a predetermination of your shooting location, a detailed schedule and suggested camera settings, along with the appropriate lenses and any specialized equipment that you might need for all your shots. Sounds good, right?

Spending the time beforehand to clearly think through your objectives will help you stay on track when you are in the field. It will allow you to concentrate on the creative aspects of your session instead of getting bogged down in technical details and distractions that could have been minimized or avoided altogether.

Having a plan will make the difference between being unpleasantly surprised by the unexpected appearance, or lack thereof, of a crucial night sky object; or enjoying the confirmation of observing an anticipated sequence of astronomical events unfolding on schedule before your eyes. There are six main steps:

(1) developing the concept;
(2) choosing the shooting location and date;
(c) choosing the shooting time;
(d) selecting the appropriate lens and appropriate exposure settings, and,
(e) summarizing your plans and timeline for the session.

It's easier than it sounds! The main reason for laying out each of these steps explicitly is to make sure we don't overlook anything. Also, this structure helps provide a logical sequence to the many decisions that you may wish to make. We will now go through each step in detail.

Pre-Visualization and Developing the Concept.

Begin your planning process with a specific concept in mind; be it star trails, an image of the Milky Way, a meteor shower, or perhaps the full moon rising.

Better yet, pre-visualize your nightscape image—close your eyes and think carefully about the image you'd like to create. Be as detailed as possible; is there a specific foreground subject in your image like a particular mountain peak or a well-known rock arch; or more general subjects like patches of wildflowers or a lake with a fishing pier?

How are the night sky objects positioned relative to the foreground; does the Milky Way appear to rise directly upwards out of a river or waterfall; or does it arch horizontally across the sky? If you are creating star trails, how exactly are they oriented relative to the horizon—do they angle upwards, curve across the horizon, or form complete circles?

How well illuminated is the foreground; are you looking for dark silhouettes, or is a well-lit foreground important? Is the moon rising over, or next to some historic or natural landmark?

While it may sound obvious, pre-visualizing your images gives you the answers needed to narrow down your choices of dates, times, locations, lens choices, camera setting, and exposure strategies to those that will practically guarantee that you'll return home with memory cards chock full of exciting images!

Having a pre-visualized scene in mind also helps enormously as you scout your destination during both the day and at night. I have experienced déjà vu many times as I've come across scenes that uncannily match their pre-visualized version; the process of pre-visualization can help in "knowing" when you've arrived at a good spot.

Also, it is always surprising how many unexpected distractions develop in the field to pry your attention away from the subtleties of composition. For example, mosquitoes, thick brush, ticks, incipient clouds, incipient moonrise, cold, wind, difficulty in achieving focus, lights from other people, dying batteries, dehydration, not getting lost and even sleepiness can all interfere with the creative process of landscape astrophotography.

Having a well thought out, pre-visualized image in mind, with all the critical elements clearly identified, helps keep you on track.

Choosing azimuth and altitude of the night sky subject.

The next phase of planning involves identifying the general compass direction, or azimuth of your night sky subject on the selected dates, along with its height above the horizon, or its altitude, measured in degree. While you may recall correctly that the azimuth and altitude of night sky objects change during the night, we only need to assess their general range at this stage.

You may obtain the azimuth and altitude of your night sky subjects at various times on your candidate dates with the help of the star charts, planispheres, and planetarium. Monthly publications of star charts are available online, and also appear in magazines such as Astronomy or Sky & Telescope. Several useful apps and programs are also available such as Distant Suns, Star Walk, Stellarium, and Google Sky.

Choosing the Location.

We can now explore a few locations where we might set up our equipment for the night, provided a suitable foreground subject is available. Start with a location with the darkest possible skies, free from cities and other sources of light pollution. Even if your general destination is dictated by other constraints, it is worthwhile driving a short distance if it can help alleviate light pollution levels.

Choosing Lens and Camera Settings.

The last stage of preparation before we summarize our overall plan is to select the appropriate lens and exposure settings. Lens selection can be done with reference to the lens field of view (FOV. Namely, you will want to select the appropriate lens needed to create your pre-visualized image based upon the azimuth and altitude requirements of your night sky subject(s) as well as the necessary FOV needed to include your foreground.

For example, if you wish to create a star trails image with trails encircling the North Star with land-based foreground objects also visible, then the angular FOV of the lens must be wide enough to exceed the angular position of the North Star above the horizon, which you may recall is approximately equal to your latitude.

Alternatively, if you wish to create a Milky Way image, you will want to select a lens with a narrower FOV; e.g. one with a focal length of 35 mm or greater. Finally, if you wish to create an image containing a specific range of constellations, for example, Sagittarius and Scorpius, then you'll need to match the FOV of your lens to the required FOV of the constellations, which can be obtained from the simulation apps.

Choosing and mounting the correct lens ahead of time avoids the significant hassle and time wastage associated with the necessity of changing lenses in the field owing to an inappropriate FOV; something easily avoidable with proper preparation.

Next, you can identify a good starting point for each of the camera's exposure settings: ISO, aperture and shutter speed. The specific settings you will settle upon once you're in the field will undoubtedly change; the estimated initial values nonetheless reduce the number of decisions you need to make when you're setting up in the dark with many other distractions likely competing for your attention.

Equipped with the likely lens and aperture combination suitable for your nightscape image, one final parameter to check is the near-focus distance of the chosen lens and aperture combination. This will be the case either with a focus distance of infinity or through hyperfocal focusing. You will recall that the near-focus distance dictates the closest distance an object can be from the camera and still remain in focus. If, however, part of the foreground is still too close to the lens despite your best efforts, all is not lost.

Developing the Landscape Astrophotography Workflow and Plan.

The culminating stage of our planning process is to summarize our ideas in the form of a worksheet and overall schedule for the astrophotography session.

This schedule will include a time estimate for all the images we wish to acquire. This is extremely important since many of the images and image sequences can consume a surprising amount of time. For example, a multi-image Milky Way panorama comprised

of twelve 2-minute apiece exposures will take approximately one-half hour. And that's just for one (really good!) image.

A single star trail image can take 4 or 5 hours! Furthermore, you may wish to change lenses midway through your shooting session; something that is best kept to an absolute minimum when you're in the field.

Finally, different images may necessitate specialized equipment that you will want to ensure you have before heading into the field for the night, such as intervalometers, panoramic heads, lens filters, tracking heads, and so on. Clearly, scheduling and prioritizing the sequence of what images to take with which lenses, is critical.

Essential Software and Apps.

Today's landscape astrophotographers are fortunate to have access to a large and ever increasing variety of sophisticated, free, or low cost software and apps specially tailored to their needs. These tools have revolutionized landscape astrophotography, especially when used on mobile devices.

For example, it is now possible to pinpoint the precise location, within a few feet in the field where you should assemble your camera and tripod to capture the full moon rising directly over a distant landmark hours, or even days, before the actual event! The tools listed here are simply representative of the types of tools you may find helpful. The ones that are described here are ones that I have personally used at home and in the field on many occasions.

Astronomy.

Astronomy software programs and apps allow you to explore the night skies in virtual reality for any date, past, present, or future. Many are freely available and have an extraordinary level of detail. They generally include clickable objects linked to further information or databases. Many apps include an augmented reality capability for use on mobile devices, where the app will display the night sky view corresponding to the orientation of the mobile device.

These simulation programs are valuable for many reasons. First, they allow you to gain an appreciation of the visible objects during different times of the year. You can search for specific objects to determine the best times to observe them. They allow you to simulate the movement of objects in the night sky, so you can quickly gain an appreciation of the direction of their motion and how it depends on azimuth and altitude.

Many have built in databases for the orbital trajectories of the International Space Station and major satellites. Two popular simulation programs for desktop or laptop systems are Stellarium and Starry Night. Both allow you to create a virtual planetarium and explore the night sky in detail.

You can determine what objects are visible in the night sky for any place on Earth. You can estimate the field of view (FOV) necessary to photograph the objects of interest, allowing you choose the appropriate lens. Both programs allow you to simulate the passage of time in order to assess how the night sky objects move

during the night, as well as over the course of days, months, and even years!

Having this knowledge before you venture into the field can save you immeasurable amounts of time, energy and frustration. Also, there is something almost magical about watching night sky objects emerge from twilight precisely as predicted.

There are a number of apps for mobile devices that function in an equivalent manner. In addition to Stellarium, the ones that I use most frequently are Distant Suns and Star Walk. Both use the local coordinates of the user obtained from the GPS sensors of the device to calibrate the current view of the night sky. All also give you the option of manually entering an observing position anywhere on Earth to assess how the view of the night sky will appear from that location.

This feature is very useful for exploring the appearances of the night skies while planning a trip to distant locations. Finally, you have the option of setting a "Night Vision" mode, in which the mobile device screen is lit with red light, to help protect your night vision, instead of its normal bluish tints. As an example, we might begin our session by opening the app, confirming the correct location, and then scrolling around the horizon and zenith to see what night sky objects will be visible that evening at different times.

We might visit the southern or northern horizons to view the Milky Way and determine its azimuth at different times of night. As we have seen for both sky-priority and foreground-priority images,

we are often interested in determining the times when the Milky Way is positioned at a specific azimuth or with a certain orientation.

We might also change the date and/or location to explore their effects. Finally, the PhotoPills (PP) and The Photographer's Ephemeris (TPE) apps both deserve mention in this section owing to their wealth of astronomical data, including a moon phase calendar. Making these assessments before heading into the field saves time and allows you to position yourself in prime locations.

Photography—Processing Tools.

By far the dominant software for image post processing are Adobe Photoshop and Adobe Lightroom. The fundamental reason both programs have gained such widespread use is their inherent ability to allow you to make non-destructive editing adjustments to your images without permanently affecting the original image.

Many other software tools, or "plug-ins," have been developed to perform specialized functions within Photoshop and Lightroom that is beyond the scope of this guide but you can read in detail about on the web.

General Field Gear.

There are two items I never leave behind whenever I venture into the field for a nightscape photo session:

A reliable headlamp equipped with a red light setting, and, a compass.

No other pieces of equipment are so important to your personal safety. If you've never used a headlamp, you'll be astonished at how useful they are— both hands are kept free and the light always shines right where you're looking. In fact, you should always carry a spare!

You may also want to bring a second hand-held flashlight as well. It is helpful for lighting the trail, light-painting projects, and a myriad of other tasks. Finally, don't forget duplicate sets of spare batteries.

A compass is invaluable at getting oriented in new surroundings. I frequently use mine during the day to estimate the future locations of night sky objects, thus narrowing down choices of scene composition. Be sure to choose one that allows you to correct for the difference between true and magnetic north, or the magnetic declination. A magnetic declination adjustment is helpful since the earth's magnetic North Pole is offset slightly from its physical North Pole.

Such models are often described as orienteering compasses. Correcting your compass for magnetic declination allows you to take readings directly from its dial while allowing the compass needle to point to magnetic north. Your cellphone can also be invaluable in the field, even without coverage.

Used with the apps described above, it can provide times of sunset/sunrise, moonset/moonrise and twilights, photography settings, as well as the positions and orientations of sky objects. A small, rechargeable power supply can be a helpful accessory if its power runs low. Finally, it may be able to summon emergency services, although coverage in remote areas is unreliable and often nonexistent.

Another vital device to carry into the field is a dedicated GPS device. Most of the time it's not needed, but it can make an enormous difference if you become lost. Such devices are also invaluable at navigating in areas with limited coverage by cellphones, and have the added benefit of providing precise position coordinates for pinpointing your position. Many models feature a "go-to" capability, which allows you to navigate to a specific destination, for example, your car, or camp at the end of the session.

I have relied on this feature on several occasions to return from a nightscape session in dark, featureless surroundings. A roll of gaffer's tape—photographer's "duct tape" is a surprisingly useful accessory to keep in your camera bag. There are innumerable uses for it, from securing loose cables, to serving as a shim for a loose lens cap, taping handwarmers to your camera - you will be glad you brought it along.

A simple chair has the ability to transform an evening of nightscape photography from a battle of endurance to a relaxing night in the outdoors. Backpack chairs are perfect for carrying equipment and supplies a short distance, and also help whenever a

brief (or long!) nap is needed. A dedicated camera backpack, however, is your best option for longer hikes.

Camera backpacks typically have myriad padded and zippered compartments for all your gear along with a carrying pouch for your tripod. You can use them to carry a surprising amount of gear quite a long distance.

In cold-weather destinations, any of the available handwarmers are a wonderful way to stave off chilly, damp night air. They can also be used to keep your camera and batteries warm either by taping them in place with gaffer's tape, attaching them via rubber bands, or even elasticized bandage wraps. Attached to your lens body, they can also help avoid dew formation and frost.

There are several miscellaneous items that are worth considering. I often keep a few energy bars, trail mix, or pieces of fruit inside my bag for a late night energy boost. A thermos of hot chocolate, tea, or coffee can also make a world of difference. I generally keep a fleece hat, gloves, nylon windbreaker, and a bandanna on hand in case temperatures drop unexpectedly.

You may wish to create a dedicated waterproof bag of sunscreen, insect repellent, and antibacterial disposable hand wipes; you never know when annoying insects can suddenly materialize and cause mischief. Earplugs and a headscarf or bandanna are also great at keeping insects and cool breezes at bay.

I always keep a small roll of toilet paper and a backpacking hand shovel tucked inside my bag in case a restroom isn't nearby, and I'm

on suitable public land. Finally, in bear habitat, a can of bear spray is good insurance. While this guide is no substitute for a complete course in bear safety, good bear-safety habits are vital for the bear's health, as well as your own, and must be adopted whenever you travel in bear country, especially areas inhabited by North American grizzly bears.

Astronomy gear.

I always carry a planisphere with me when I venture into the night, preferably one with glow-in-the-dark markings. Not only does it allow me to readily confirm the identity of specific objects, it helps in understanding how they move throughout the night. I also carry a green laser pointer (5 mW or less) to help in identifying night sky objects to others.

Photography gear.

The absolute necessities are your camera, tripod, memory cards, and batteries. It is a good practice to confirm that your camera actually contains its memory card and battery before leaving for your destination.

While it may seem obvious, on more than one occasion, I have hiked into a pre-dawn location only to find an empty memory card slot in my camera and no spare memory cards in my pack—I had simply overlooked them and failed to check! Other essential gear includes a remote shutter release or an intervalometer, a color correction tool, a flashlight for light painting, a handheld loupe to

assist in focusing on the stars, and a dust blower to keep the lenses clean.

Beyond these basics, I will occasionally bring along assorted filters, a panoramic head, a flash, and wireless remote triggers. If I intend to perform very long exposure star trails, I will bring the external battery pack for the camera and/or an external camera power supply. Small patches of Velcro and tabs attached to the upper legs of my tripod can help keep the intervalometer and other cables in order and untangled.

Five best astrophotography targets and how to capture them.

Aurora Borealis/Australis.

LENS (MM): Fisheye, 14–50
START: Late astronomical twilight to full darkness
ISO: 1600–12800
END: Early astronomical twilight (predawn)
APERTURE: sharpest
SHUTTER (SEC): Adjust as needed
COMMENT: Keep shutter speed low to retain structure.

Blue Hour.

LENS (MM): All
START: Evening - End of sunset; Morning - Beginning of astronomical twilight
ISO: Low (100–500)
END: Evening- End of astronomical twilight; Morning- Beginning of sunrise
APERTURE: Sharpest (minimum + 2 stops)
SHUTTER (SEC): Adjust as needed
COMMENT: Easy image to make; good silhouette opportunity.

Cityscapes.

LENS (MM): All; generally wide-angle
START: Golden hour (sunset)
ISO: 100–1600
END: Golden hour (sunrise)
APERTURE: Sharpest (minimum + 2 stops)
SHUTTER (SEC): Adjust as needed
COMMENT Good FLW filter opportunity during civil/nautical twilight

Constellations.

LENS (MM): Fisheye, 14–35
START: Mid-astronomical twilight (postsunset)
ISO: 1600–12800
END: Mid-astronomical twilight (predawn)
APERTURE: Minimum— sharpest
SHUTTER (SEC): Focal length (mm)/ 500
COMMENT: Good fog filter opportunity

Lunar Eclipse.

LENS (MM): 24 mm and higher
START: Mid-civil twilight (postsunset)
ISO: 100–1600
END: Mid-civil twilight (predawn)
APERTURE: Sharpest (minimum + 2 stops)

SHUTTER (SEC): Adjust as needed
COMMENT: Requires planning

COMMON ASTROPHOTOGRAPHY OBSTACLES & HOW TO SOLVE THEM.

This articles aims to describe the most common obstacles you're likely to encounter in your nightscape quests, and ways to mitigate them. The goal is to help you maximize your enjoyment by developing strategies ahead of time for coping with the inevitable challenges and potential frustrations that accompany any outdoor activity.

With patience, perseverance, skill, and good luck, you will be rewarded with one or more high-quality images that you will be proud to hang for display or videos you will be excited to share. Although challenging, landscape astrophotography is a rewarding pursuit that you can learn and improve through practice, provided you give yourself enough time.

Logistics—Time, Travel, and Costs.

There are several fundamental logistical challenges to nightscape astrophotography. There can be major time investments involved in planning, traveling, and creating beautiful images. Objects move inexorably across the night sky. The costs of landscape astrophotography equipment and travel can add up. It is important to

recognize these time and potential cost logistics so you make appropriate decisions and suitable preparations.

The large number of extraordinary nightscape images that we constantly see on social and commercial media, art exhibitions, television, and film documentaries have spoiled us. They make it easy to underestimate how difficult and time-consuming it is to actually create them. Planning and completing a successful landscape astrophotography session can take far longer than one might think. In many cases, we need to book airline tickets, rental cars, hotel accommodations, spend a day flying, and then driving hundreds of miles to reach our ultimate, unfamiliar destination.

Once there, we need to unpack and prepare for the evening's events. We need to carry our equipment to the shooting location and set it up during our scouting explorations during the day as well as our shooting expedition at night. Then, provided the weather holds, we will likely spend several more hours collecting images before returning home and spending, yet more hours post-processing them.

Night sky objects move with a seeming relentless consistency. There is no rewind button. Once the moon has crossed the horizon there is no going back. Once the Milky Way has begun to set, that's it for the evening. Try measuring the time it takes for the sun to completely disappear beneath the horizon after first touching it. You might be surprised to find it is only a few minutes. The moon takes even less time.

On more nights than I can remember, image possibilities have slipped away as I have dithered, unsure of which image or image

sequence I should take next! It really pays to have carefully thought through which images you wish to shoot during a given evening, and in what order, and with which camera and lens combination.

Having even a cursory written plan can be remarkably helpful late at night when you are cold and tired; having the detailed plan we developed can really pay off. It can make the difference between coming home with memory cards full of images or coming home imagining what might have been possible if only there had been more preparations or time available.

By now you realize that I am a firm believer in the value of thoroughly preplanning your trips. In addition to assessing the logistics discussed above, you may wish to estimate how much time you will need to create your image(s)—and then double it. Now you will have a reasonable buffer to deal with all the inconvenient realities of working in the field—airplanes and satellites flying through your shot, headlights from a car ruining a time-lapse sequence, needing to re-focus, changing a dead battery, trying a second composition…the list is endless.

Setting Up at Night.

You may find it helpful to arrive on-site at least an hour before your earliest shooting time. In addition, be sure to allow ample time to park, load up your gear, and hike in to the destination. Even though you have scouted the site, determined the best tripod location and reviewed your images from the day and chosen your favorites, everything takes longer than you might think! Simply setting up the tripod, acquiring focus, fine-tuning the composition, and setting

exposures all take time. The worst feeling in the world is to be late to an event that simply can't be replayed.

Focusing in the Dark.

Focusing in the dark is probably the biggest technical challenge to those beginning in landscape astrophotography. Since it is done with your camera and/or your lens set to a manual focus setting, it is entirely up to you to achieve the best focus possible. You may spend all of your first night, or two, or even three or more mastering this vital skill. A sharp focus is critically important; blurry, out-of-focus stars will ruin an otherwise perfect image. It is important to be patient and give yourself time to learn this skill. Practicing at home will save you great frustration when you are in the field.

Many higher-quality lenses have a marking on the barrel that indicates a focus distance of infinity, ∞. While it would seem straightforward to simply set the focus ring to the setting, pinpoint focus of night sky objects is rarely achieved by doing so, most certainly so for zoom lenses. Changes in temperature, for example, can cause dimensional changes in lens components that lead to tiny, yet noticeable, focus imperfections. Changes in the lens zoom setting can discernibly shift the focus position as well.

I prefer to always focus directly on the stars themselves, thus ensuring the sharpest and most reliable focus of the night sky. Since stars are too dim to see clearly through the viewfinder, however, you must rely on the live-view feature of your camera. This process can be extremely challenging to perform in the field.

A handheld loupe can assist in viewing the stars on your camera's liquid-crystal display (LCD). An alternative is to focus on the distant horizon, instead of the stars, before the end of civil twilight, and simply maintain this focus setting throughout the night. Another approach is to find a distance light on the horizon and to use it as a focusing target, again instead of the stars. Once you have achieved focus, you might like to tape the focus ring in position with gaffer's tape.

Memory Cards and Batteries.

Multiple spare camera batteries and memory cards should always accompany you into the field. Just like all equipment, both can occasionally malfunction. You will always want to have an extra empty memory card and fully charged battery on hand, just in case.

Nothing is worse than being in the middle of an exciting shoot, only to realize that you have exhausted your memory, or drained your battery, and if only you had a spare replacement, the shoot could go on. They are such small objects, yet they have the potential to enable or completely end an entire night's shooting. Finally, always check that your camera actually contains its memory card and battery before venturing into the field.

All of us, at one time or another, have driven to our night's destination, excitedly hiked up the trail to reach our shooting location, pulled out our camera only to realize its battery is still at home, plugged into the battery charger! There are a number of methods for carrying spare memory cards, including wallets, sleeves, and plastic cases.

One important reminder: be careful to never touch the gold-colored metal contacts on camera memory cards with any part of your body. Doing so inadvertently may trigger a discharge of static electricity from your body through the card. This electrical discharge may then interfere with and corrupt the data stored on the card, and ultimately the entire card itself. Batteries generate electricity via internal chemical reactions. The strength of the reactions depends strongly on the ambient temperature.

If the temperature is too low, then the rate of the chemical reactions slows, significantly reducing the level of electrical output. This reduced output is manifested as a shortened battery life. Solutions to this potential problem all involve keeping your camera batteries as warm as possible.

On many occasions, I have successfully revived seemingly dead batteries simply by warming them in my hands or in a trouser pocket for several minutes. Attaching portable handwarmers to the camera body with tape, rubber bands, or other methods can prolong the battery life in the camera. Handwarmers also help keep the inner mechanisms of the camera working smoothly at sub-zero temperatures.

Other Issues.

There are several camera settings that can pose problems if neglected. Here are just a few examples; it is always a good idea to create a list of these and other potential problems that you actually consult in the field, so as to ensure smooth operation and a successful outing:

Ensure your camera/lens is set to manual focus.

Adjust the zoom setting of your lens before establishing focus.

Be sure to turn off the long-exposure noise reduction setting during the collection of star trail images, otherwise the star trails will be dashed lines, with the gaps corresponding to the periods when the noise reduction was being performed.

When conducting a sequence of images using an internal or external interval timer, it is important that the image collection period be longer than the shutter speed. Be sure to monitor the ISO so that it is not higher than necessary.

Monitor the focus throughout the shoot; it is all too easy to accidentally and unknowingly bump the lens during the night, knocking it out of focus.

Depending on the complexity of your night's operation, you may end up with a number of electrical cables attached to your camera. It is important not to accidentally snag one and unintentionally shift the camera and tripod.

If you are using a tracking head for the tripod that requires external power cables, take care to ensure they have enough slack to allow for the tracking head's movement as the night progresses. Be sure each section of the tripod and head is fully secure.

Adjust your camera's LCD brightness to its minimum level to preserve your night vision and the camera battery life. Turn off your camera's image review feature to also preserve battery life.

CAMERAS AND IMAGING IN ASTROPHOTOGRAPHY.

There are many options available to the astrophotographer that cover a range of budgets and sophistication. Things can be exceedingly simple - a normal camera on a static tripod or mount - or they can quickly become more sophisticated, using dedicated CCD cameras with a motorized filter wheel and autoguiders.

Without the digital sensor, modern astrophotography would be a very different experience. Understanding the limitations of a digital sensor is pretty significant and your choice of camera has a large impact on system choices and budget. Their various properties play a pivotal role in the end result and these properties are mentioned throughout the article.

Using your existing digital camera (often fitted with a CMOS sensor) with a motorized mount is a great place to start and for some, this solution can meet their needs for a while.

There are several excellent books that concentrate on conventional camera-based astrophotography. At one time, this was limited to digital SLRs, but increasingly this can also be with one of the many mirror-less cameras that have interchangeable lenses, either using a telephoto lens or attached to the rear of a telescope using a simple adaptor.

Conventional Digital Cameras.

It makes sense to kick off astrophotography using your existing digital camera. All the main camera brands have their devotees and critics and although I might be shot for saying so, there is not much to choose between them. In astrophotography however, there are a few specialist requirements that favor a few brands. These are: remote operation and good quality long exposures.

Remote Operation.

SLR and mirror-less cameras are both capable for use in astrophotography. Focusing is an unavoidable requirement in any setup. Even with 10x image magnification on its LCD screen, it is very difficult to judge the precise focus on any star, even with a focusing aid such as a Bahtinov Mask. With the right software, however, and tethered operation over a USB connection, things become much tidier; imaging software takes repeated images whilst you adjust the focus and plots the FWHM or HFD (half flux diameter) for each exposure.

The best focus is achieved when the FWHM is at its lowest value. Although several camera brands supply general software utilities for remote capture, it is the third-party apps and full astrophotography programs that have the tools to assess focus accuracy.

At present, the best-supported SLR brand by astronomy programs is Canon EOS. The modern cameras operate via their USB

connections but not all support long exposures (greater than 30 seconds) directly. Those models and the older pre-USB models can be triggered with a modified electric cable release and an interface circuit to a PC.

Long exposures consume batteries and several will be needed for a full nights imaging. The process of changing batteries can disturb the imaging alignment and for uninterrupted operation, a battery adaptor powered from 12 Volts is a better option.

The battery adaptors supplied by the OEMs or third-party retailers comprise a battery adaptor and a small DC power supply, powered by mains. With a little ingenuity a small variable DC-DC converter module can be housed in a small plastic box and adjusted to provide the exact same DC voltage at the camera end, from a 12-volt power source. This is a safe and reliable alternative and can share the local 12-volt DC source.

Image Quality.

Camera shake from a SLR mirror and shutter is not an issue during long exposures, as any vibration fades in milliseconds. There are a few settings on a camera, however, that you need to take care of to extract the best quality. All digital cameras have a long-exposure noise-reduction option, which takes and subtracts a single dark frame exposure from the image. This is not sufficient for high-quality astrophotography and should be disabled.

It is also really important to use unmolested RAW files in the highest possible bit depth and without any interference from any in-

camera processing. For best results, images are stored in the camera's native RAW file format and to reduce thermal noise, any toasty "Live View" option is turned off whenever possible.

RAW files are not always what they seem; keen-eyed amateurs have noted that some older Nikon cameras process RAW files and mistakenly treat faint stars as hot-pixels and remove them.

Additionally RAW files are not quite as unadulterated we are lead to believe. All the cameras I have tried have to some extent manipulated the RAW data in camera. This undisclosed manipulation is often detected in weird dark current results and require special attention during image calibration prior to stacking.

Image processing, especially with deep space images, severely distorts the tonal range to show faint detail and requires the highest tonal resolution it can muster. Most digital cameras have 12- or 14-bit resolution in their sensor electronics.

These produce 212 (4,096) to 214 (16,384) light levels for red, green and blue light, stored in a 16-bit file format. Image processing on the combined image files averages between exposures and creates a higher tonal resolution that ideally uses 32-bits per channel. JPEG files on the other hand have just 8-bits per channel resolution and this is insufficient to withstand extreme image processing without displaying abrupt tone changes (posterization).

Choosing a RAW file format also bypasses any in-camera high-ISO noise reduction modes that generally mess things up. In-camera noise reduction typically blurs the image to reduce the apparent

noise but in doing so, destroys fine detail. For a static subject there are far more effective means to reduce shadow noise and astrophotographers use multiple exposures combined with statistical techniques to reduce image noise in dim images.

It is easy to imagine the benefits of remote operation. In addition to the welcome convenience during a long exposure sequence there are sometimes less obvious benefits to imaging quality too. A third, lesser-known benefit of remote operation occurs during the conversion from the separate RAW sensor element values to a RGB color image.

Camera RAW files require processing (de-Bayering) to create a color image from the individually filtered sensor values. The standard RAW converters used by photographers and the standard RAW converters apply some averaging (interpolation) between adjacent sensor elements for pictorial smoothness. (Some cameras additionally have an anti-alias filter, a sort of mild diffuser, in front of the sensor that accomplishes the same thing.) In general photography, an antialias filter trades resolution for smoothness and is most needed to depict straight lines without jagged edges or strange colored banding.

While this is important for normal pictures it is all but irrelevant to astrophotography as there are no straight lines. Several astrophotography programs use their own optimized algorithms (especially for star-fields) that preserve and later convert the individual RGB information into a 16- or 32-bit RGB FITS or TIFF image file.

If you have the choice, choose remote tethered image capture, using an astrophotography program rather than store on the memory card. Photography and astrophotography have different visual needs and the specialist capture programs are optimized for the purpose.

Color Sensitivity.

The individual sensor elements (some texts refer to these as photosites) in a CMOS or CCD have a broad color sensitivity that extends from ultraviolet (UV), through visible and includes infrared (IR) light. Video camcorder "night-shot" modes make good use of the extended infrared sensitivity but this is not a desirable feature in either general photography or astronomy.

Infrared light will focus to a different point through any refractive optic and even color corrected compound elements will refract visible and infrared light to a different extent. The outcome is a blurred image. (Mirrors reflect all light by the same amount but any glass-based correction optic may introduce the problem just before the sensor.) The answer is to block IR (and UV) light from the sensor.

The filters used in a color sensor's Bayer array are not sufficient and an additional IR blocking filter is required to stop infrared light reaching the sensor. In general, the efficiency of a photographic camera is less than that of a filtered monochrome CCD and in some models, the added IR filter progressively reduces the light intensity of deep red light even more. (The primary color of emission nebula is a deep red from ionized hydrogen (Ha) at 656 nm and an even deeper red from ionized sulfur (SII) at 672 nm.) In these instances, a

longer exposure is required to detect the faint glow, with the added risk of higher image noise and over-exposed stars in the region.

The standard Canon EOS camera bodies currently have the best third-party software support but at the same time their IR filters reduce the intensity of these important wavelengths by 80%, To their credit, Canon marketed two unfiltered bodies specifically for astrophotography (the EOS 20Da and 60Da).

These cameras are not cheap and many use a consumer model or a used body and the services of a third-party company to remove or replace the infrared blocking filter. This modification improves the deep red sensitivity and depending on whether the IR filter is simply removed or replaced, may affect color balance and autofocus.

Light Pollution.

A camera's color sensor is also sensitive to visible light-pollution. Although light-pollution filters block the principal street-lamp colors and reduce the background light intensity, they also reduce star intensity at the same time.

They require color correction to remove their characteristic blue or green color cast. These filters mount in the camera lens throat (Canon EOS) or on the end of a T-thread to telescope adaptor (1.25- or 2-inch). Light pollution filters can perhaps be more accurately described as nebula filters, since they pass the specific nebulae emission wavelengths, which thankfully are not the same as those found in urban light pollution.

The result is that image contrast is improved and requires less manipulation to tease out faint details. Whilst on the subject of light pollution, the intense reflected light from a full Moon can wreck a nights imaging. No light pollution filter can remove this broad-band sky illumination.

Dedicated CCD cameras.

In the beginning, SLR cameras used both CCD and CMOS sensors in equal measure. Although CCD sensors have less noise, CMOS sensors have become more commonplace since they are cheaper to produce, use less power and through gradual development have narrowed the gap to a CCD's noise performance.

High-quality dedicated astrophotography cameras still use CCDs exclusively, with the exception of some small format cameras designed for autoguiding and planetary imaging. These two applications only require short exposures and in practice are more tolerant to image noise. The uptake of camera sensors into astrophotography is quite slow. Most CCDs are made by Sony and Kodak and come in a range of sizes and resolutions. The larger ones often require a physical shutter and have interlaced rather than progressive readouts.

These require a little more care; moving shutters can disturb dust in the sensor housing and interlaced outputs may need a processing adjustment to ensure alternate lines have the same intensity. Dedicated CCD cameras represent a substantial investment. There is no way of softening the blow but a used one is about the same price as a new semi-professional SLR. These are hand-made niche

products without economies of scale. Having said that, each year more astronomy CCD cameras are launched and with better sensor performance for the same outlay.

Model turnover is much slower than that of consumer cameras and dedicated CCD cameras hold their value for longer. Once you have a CCD, there are only really three reasons for upgrading: better noise, bigger area or more pixels. The latter two will be practically capped by the telescope's imaging field of view, the resolution limit of the system and seeing conditions.

Light Pollution.

Dedicated cameras come in color and monochrome versions. The "one-shot" color cameras use the familiar color Bayer array and share some of the limitations of their photographic cousins and as a consequence are equally susceptible to light pollution. The monochrome versions have a significant advantage over one-shot and color sensors, since the user has complete control over filtration.

With a monochrome sensor, a single filter is placed over the entire sensor, one at a time and all the sensor elements contribute to each exposure. The designs of the individual filters (RGB, luminance and narrowband) maximize the contrast between the deep space objects and the sky background. The specialist dichroic red, green and blue filters are subtly different to their microscopic cousins in a Bayer array. The spectrums of the red and green filters do not overlap and effectively block the annoying yellow sodium street lamp glow that is a major proportion of light pollution is. In

addition to the normal RGB filters, there are a number of specialist narrowband filters, precisely tuned to an ionized gas wavelength.

These pass only the desirable light emissions from nebulae but block light pollution, so much so that "narrowband" imaging is very popular with city-bound astrophotographers. The Hubble Space Telescope uses Hα, OIII and SII dichroic filters, the "Hubble Palette". This produces fantastic false-color images, by assigning the separate exposures to red, green and blue channels in a conventional color image.

Color Sensitivity.

Dedicated cameras are the epitome of less-is-more; without the infrared blocking filter, they have a better deep-red sensitivity than their SLR counterparts, limited to the sensor itself. They still need a UV and IR blocking filter (often called a luminance filter or "L") but the astronomy screw-in ones do not impair the deep red visible wavelengths.

The decision between one-shot color and monochrome is really one of priorities: Monochrome sensors offers more versatility but with the extra expense of a separate filters or a filter wheel and require a longer time to take separate exposures to make up a color image. Arguably, there is better resolution and color depth using a monochrome sensor through separate filters, since all sensor elements contribute in all exposures.

A common technique is to combine or "bin" red, green and blue filters to color a simple high-resolution monochrome image, taken

through a plain UV/IR blocking filter. The human eye's color resolution is lower than its monochrome and the brain is fooled by a high-resolution image with a low-resolution color wash.

Thermal Noise.

Many dedicated CCD sensors employ an electric cooling system by mounting the sensor chip onto a Peltier cooler. This special heat sink has a sandwich construction and effectively pumps heat from one side to the other when a voltage is applied across it.

Alternating n- and p-type semiconductors are the "meat" and have the unique property of creating a thermal gradient between the opposite surfaces. A single "Peltier" cooler can reduce a sensor temperature by about 25°C, with immediate benefits to thermal noise. Some cameras have a 2-stage cooler that can keep a sensor about 40°C lower than ambient temperature. The practical limit to cooling is around the -20°C mark.

At this temperature, in all but the darkest sites, sky noise is dominant in the image and there is no observable benefit from a further sensor cooling. There is a downside too from over-cooling; extreme cooling may cause ice to form on the cold sensor surface and for that reason most CCD modules have a desiccant system to reduce the chance of condensation in the sensor chamber. Desiccants can saturate over time and higher-end camera models seal the sensor cavity and fill it with dry argon gas or have replaceable desiccants.

Cameras for Planetary Imaging.

Apart from taking still images of very dim objects, another popular pursuit for good cameras is planetary imaging. The closer planets are considerably brighter than deep space objects and present a number of unique imaging challenges. Planetary imaging is done at high magnifications, usually with a special teleconverter (Barlow lens) on the end of a telescope of a focal length of about 1,000 mm or longer. Even at this long focal length the image is physically very small and will fit onto a small sensor.

Since these only span the central portion of the telescope's field of view, there is no need for a field-flattener. There is a requirement for a considerable focus extension though. This is conveniently accomplished by screwing together several extension tubes, which either fit directly to the focuser draw-tube or as a series of T2 extension tubes.

At high magnifications astronomical seeing is obvious and the trick is to take a few thousand frames at 7-60 frames per second and then align and combine the best of them.

The difference between a single frame and the final result is nothing short of miraculous. These challenges suit a sensitive CCD video camera. These output a video file via USB or FireWire. Many start with a modified webcam and upgrade later.

This is an inexpensive way to start and the modification is simple; a threaded adaptor replaces the lens, which allows the camera to fit into an eyepiece holder and hold an IR blocking filter.

There are several after-market adaptations, including support for long exposures and cooling. Several companies either dedicated to astrophotography or as adaptations of security products, market alternative CCD designs, with better resolution, lower noise and full control over video exposure, frame rate and video format.

These do give better results than webcams and with more convenience. A low cost webcam is remarkably good, however, and a lot of fun.

Please make sure to visit us at www.planetseekers.com

www.ingramcontent.com/pod-product-compliance
Lightning Source LLC
Chambersburg PA
CBHW022107170526
45157CB00004B/1519